# ANNA ATKINS'
# CYANOTYPES OF BRITISH
# AND FOREIGN FERNS

# Read & Co.

Copyright © 2023 Art Meets Science

This edition is published by Art Meets Science,
an imprint of Read & Co.

This book is copyright and may not be reproduced or copied in any
way without the express permission of the publisher in writing.

British Library Cataloguing-in-Publication Data
A catalogue record for this book is available
from the British Library.

Read & Co. is part of Read Books Ltd.
For more information visit
www.readandcobooks.co.uk

'The difficulty of making accurate drawings of objects so minute has induced me to avail myself of Sir John Herschel's beautiful proofs of cyanotype, to obtain impressions of the plants themselves which I have much pleasure in offering to my botanical friends. I hope that, in general, the impressions will be found sharp and well-defined.'

– Anna Atkins, *Photographs of British Algae: Cyanotype Impressions,* 1843

# Contents

# Introduction

Anna Atkins was an English botanist and photographer. While little remains known about her life, she is widely considered the first female photographer and the first person to publish a book illustrated with photographic images.

In a collection of delicate cyanotype impressions, Atkins changed the face of scientific documentation, creating landmark publications that captured the beauty of botanical specimens through an early photographic method.

This volume was the second collection of cyanotypes that Atkins created, following her landmark tome *Photographs of British Alage: Cyanotype Impressions*, completed in 1853. Her breathtaking cyanotypes documented the specimens of algae and ferns in ways previously unseen in botany and photography. Her volumes of Prussian blue impressions established her as a catalytic force in both fields, exploring the fascinating intersection where art meets science.

Born in Tonbridge, Kent, in 1799, Atkins was left an only child under her father's care when her mother died shortly after giving birth. Her father, John George Children, was a well-regarded scientist specialising in chemistry, mineralogy, and zoology. He was an acting member of the Royal Society and British Museum, and it was through his network of scientific acquaintances that Atkins was exposed to a world kept separate from most women of the time.

At the turn of the century, only certain hobbies were deemed acceptable for women because of their gentile nature. Along with painting, sewing, and housekeeping, botany was popular due to its association with flowers and femininity. Boasting an unusually scientific education under the tutelage of her father and his friends, Atkins developed a passion for botany, collecting and studying specimens for her collection. In 1825 she married John Pelly Atkins, a merchant of India and railway promoter, which gave her the time and means to dedicate to her botanical interests. On her travels, and through those of her friends, she collected rare specimens from around the world for her studies.

Corresponding mostly through her father, she gained much of her botanical knowledge through his friend and colleague Sir William Hooker, an established botanist and director of Kew Gardens. In a letter to Hooker on behalf of his daughter, Children states: 'I am only the channel of communication. [Atkins] considers you as her tutor in botany, as what little knowledge she possesses in the science has been chiefly derived from your works.'

Her first foray into capturing botanical specimens followed the traditional method of drawing or painting as she produced illustrations for her father's translation of Lamarck's *Genera of Shells* in 1823. Predating the advent of photography, authors relied on lengthy descriptions of specimens in their works to envisage their subjects and often pasted in hand-made illustrations and sketches or dried examples of specimens themselves, none of which provided comprehensive examples for their studies. Atkins changed the face of scientific documentation when she produced her vibrant, blue volumes of cyanotypes. Her landmark publications are now regarded as the first books illustrated with photographic illustrations, utilising the newest technology to create something never before seen in the publishing world.

By 1839, the discovery of photography had been introduced in Britain by William Henry Fox Talbot – another close acquaintance of Atkins' father. It was through this connection that the pair learnt first-hand about Talbot's new photographic

inventions. These included the photogenic drawing technique, where an object is placed on light-sensitised paper and uses the light from the sun to produce an image, and calotypes, a photographic method that uses paper coated with silver iodide that darkens when exposed to the light, creating an image in relief. Passages in Talbot's journals reveal that he sent Atkins and her father his first memoir on photography along with some of his first photographic prints. This early access to the methodology of photographs allowed the pair time to practise and experiment with techniques, with Atkins' father providing her with one of the first cameras.

The photographic process that would become Atkins' signature, the cyanotype, was developed by scientist and close family friend John Herschel in 1842 as an independent experiment on Talbot's earlier methods. The process began by mixing two iron-based compounds, ferric ammonium citrate and potassium ferricyanide, brushing the mixture over the paper's surface and leaving it in the dark to dry. The object to be photographed was then placed on the surface of the treated paper under a glass plate and exposed to sunlight for several minutes before the paper was washed with clean water and left to dry. A chemical reaction between the iron compounds, sunlight, and water, resulted in a brilliant pigment that revealed a Prussian blue negative of the object printed onto the page. This method established by Herschel later became widely known as the 'blueprint' after it was adapted by the construction industry as a way to reproduce architectural drawings.

Herschel published details of his new technique in the Royal Society's *Philosophical Transactions* publication in 1842, yet the exact chemical measurements of his method were left unspecified. There were manuals and recipes to produce cyanotypes, but only some early photographers were successful in their attempts, with many unable to get the mix of chemicals right. Luckily for Atkins, through her close relationship with Herschel, she was able to learn the technique first-hand and reproduce it perfectly.

In October 1843, Atkins published her first instalment of *Photographs of British Algae: Cyanotype Impressions* with the

illustrations intended to accompany William Henry Harvey's *Manual of British Algae*, published two years previous. She believed the appearance of the plants boasted scientific and aesthetic importance to their study and endeavoured to catalogue and classify the different types of algae in the guide. She continued to collect her specimens and produce cyanotype impressions, creating over 400 prints across multiple volumes between 1843 and 1853. It was a highly ambitious project, with the creative documentation of her botanical subjects taking a decade to complete. She writes in the introduction to her first work:

'The difficulty of making accurate drawings of objects so minute has induced me to avail myself of Sir John Herschel's beautiful proofs of cyanotype, to obtain impressions of the plants themselves which I have much pleasure in offering to my botanical friends. I hope that, in general, the impressions will be found sharp and well-defined.'

Volumes of her impressions were sent to various institutions such as the Royal Society and the British Museum, as well as contemporaries within her scientific network. Henry Fox Talbot, John Herschel, and Sir William Hooker received an early volume of the work, with each recipient responsible for organising and binding their own copy. Under 20 copies of *Photographs of British Algae* exist today, each unique in its order and number of prints due to the nature of the early publication.

In the summer of 1853, Atkins, accompanied by her close childhood friend Anne Dixon, produced a second collection of blueprints entitled *Cyanotypes of British and Foreign Ferns*. While little is known about Atkins' personal life and even less about her friend Dixon, it is believed that in the wake of her father's death earlier that year, Dixon accompanied Atkins for a lengthy summer stay at her home in Kent. During their time together, the pair produced a volume of cyanotypes dedicated to Dixon's nephew, Henry Dixon (1798–1851), who shared their enthusiasm for botany.

Like the sprawling fronds of her algae impressions, Atkins arranged her fern specimens in an equally romantic style. The intricate details of each captured in the delicate images unfurl the magic of many common British ferns. However, the pair did not confine themselves to Atkins' specimen collection, using their well-connected scientific circles and her husband's travels abroad to pool samples from around the world.

Each plant appears as if floating in water, the deep hue of the Prussian blue background provides an infinite depth in contrast to the delicate white details of each specimen. While they are impressions of static objects, the specimens hold an airy presence, their tendrils appearing in constant motion across the pages.

Their stunning colour aside, the unique outcome of each of the cyanotype prints lies in the personal touch of the hand that made them. By mixing the chemicals and applying the solution by brush to each piece of paper, the washes of Prussian blue ebb differently on each sheet. This, combined with the unpredictability of the chemical reaction with the water as they dry and the individual touches that play a part in the systematic action of creating the prints, allow for a collection of impressions each as unique as the next. Tiny white holes can be found in the corners of the images, where we can assume that Atkins pinned them up to dry. From the drip marks left by the water as it has run off the wet page in the drying process to the lighter circular smudge marks that appear when a fingertip has touched the chemical wash on the paper's surface, Atkins left her mark on each and every page of her ambitious project, with her care and dedication to the process fundamentally apparent.

As one of the first people to marry the worlds of science and photography, she saw the importance of capturing the beauty of plants in a way that only the cyanotype process offered at the time. Atkins was a pioneer of a new photographic process. She developed a unique style of reproducing imagery, resulting in a landmark publication in book publishing and scientific illustration.

Unlike her *Photographs of British Algae*, only two copies of *Cyanotypes of British and Foreign Ferns* were produced of the

same content and format— one for Dixon, another as a gift for her nephew. Through an inscription in the front of Henry Dixon's copy, we know that his volume was passed on to one of his nieces, Miss Wedderburn, who then gifted it to the Paris Lodge of the Girl's Friendly Society in the early 1900s. After the society closed its Paris branch in 1939, the volume made its way to the open market before being sold to the J. Paul Getty Museum in 1984.

In the 150 years since her death, the importance of Anna Atkins' unique work has only recently been acknowledged. Despite creating a seminal publication in the worlds of both science and photography, little is known about the life of Atkins, as it seems that she communicated primarily through her father. She died at her home in Kent in 1871, at the age of 72. While her beautiful compendium of algae was somewhat recognised around its time of publication, the volumes eventually fell through the cracks of history. They remained practically forgotten until the following century.

The last few decades have seen celebrations of her blueprints at cornerstone institutions, with the New York Public Library hosting dual exhibitions to honour her historical achievements in photography and scientific documentation. While Atkins initially presented her volumes as objects of botanical observation, they have become dynamic examples of early experimental photography.

Atkins' contributions to art and science, not to mention publishing and technology, are now receiving the recognition they deserve. This facsimile edition of *Cyanotypes of British and Foreign Ferns* captures the delicate magic of her vibrant botanical studies, taking care to reproduce the Victorian cyanotypes in their original state as a true celebration of this often-forgotten work.

Emily Gillis
Bristol, 2023

# John Herschel on the Cyanotype Process, 1842

*In a previous publication in the Royal Society's*
Philosophical Transactions, *Sir John Herschel presented
the cyanotype, his innovative photographic technique.
In this subsequent paper, he provides comprehensive
instructions and the chemical measurements necessary for
the successful reproduction of the process.*

Mix together equal measures of a saturated cold solution of corrosive sublimate, and a solution of ammonio-citrate of iron, one part by weight of the salt to eleven parts water. No immediate precipitation takes place, and before any has time to do so, the mixture must be washed over paper (which should have rather a yellowish than a bluish cast), and dried. It is now ready for use, and I do not find that it is impaired by keeping. To use it, it must be exposed to the light till a faint, but yet perfectly visible picture is impressed, and till the border (if it be an engraving which is copied) has assumed a pale brown colour. Being withdrawn it is to be brushed over as rapidly as possible with a broad flat brush, dipped in a saturated solution of prussiate (ferrocyanate) of potash diluted with three times its bulk of gum-water, so strong as just to flow freely without adhesion to the lip of the vessel. All the care that is required is, that the film of liquid be very thinly, evenly, and above all, quickly spread. Being then allowed to dry in the dark, it rarely fails to produce a good picture. And what is very remarkable, it is ipso facto fixed as soon as dry, so at least as not to be injured by exposure to common daylight, immediately; and after a few days' keeping it becomes entirely so, and will bear strong lights uninjured. By long keeping, details at first barely seen come out, and the whole picture acquires a continually-increasing intensity, without however sacrificing distinctness; and by the same gradations its colour passes from purple to greenish-blue. Some experience, to be acquired only by practice, is

necessary to determine the proper moment for withdrawing the photograph from the action of the light. If it be over-sunned, only the darker shades appear; if too little, the whole, though beautifully perfect in the first moments of its appearance, speedily runs into an indistinguishable blot.

– Sir John F. W. Herschel, from *Philosophical Transactions*, The Royal Society, November 1842

# List of Plates

## British Ferns

## Foreign Ferns

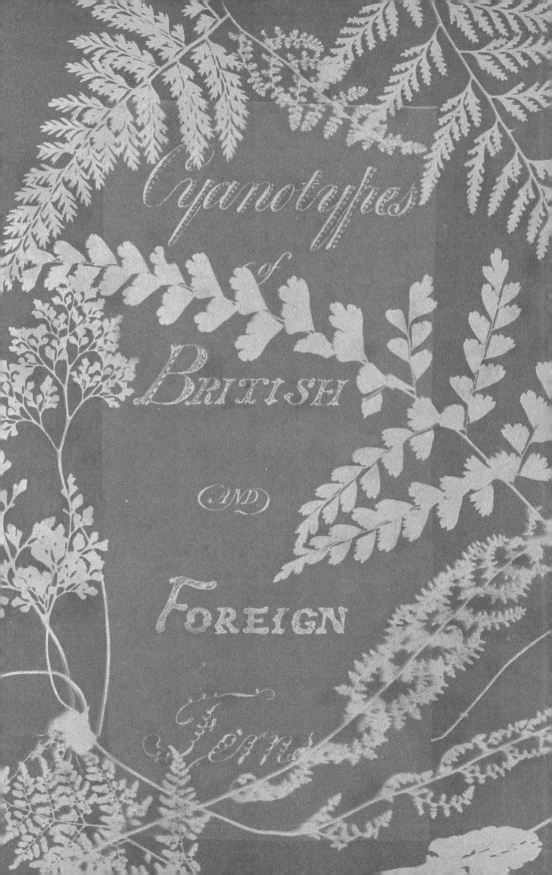

# Cyanotypes

## of

# BRITISH

### AND

# FOREIGN

## Ferns

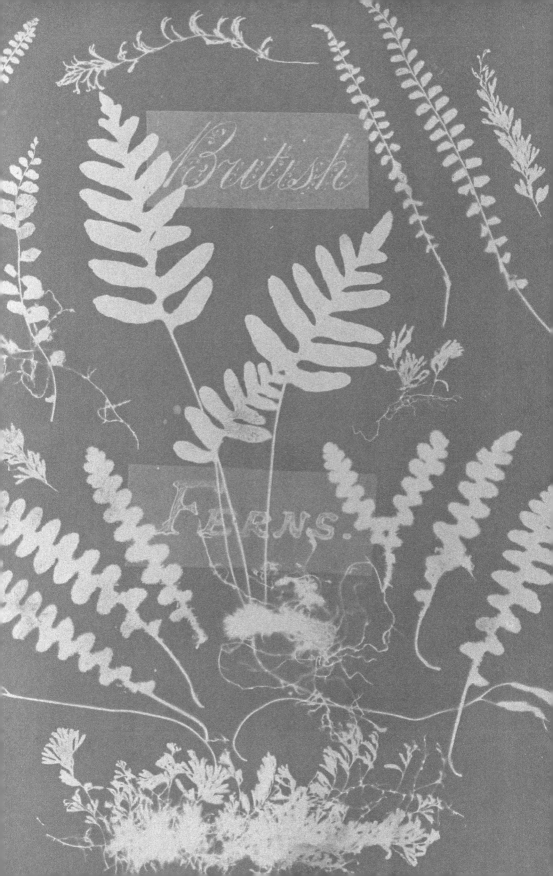

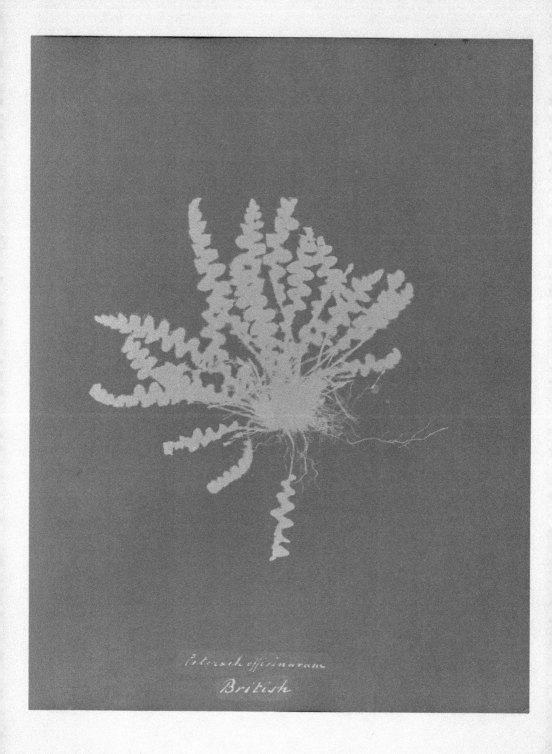

PLATE 1

Ceterach officinarum, British

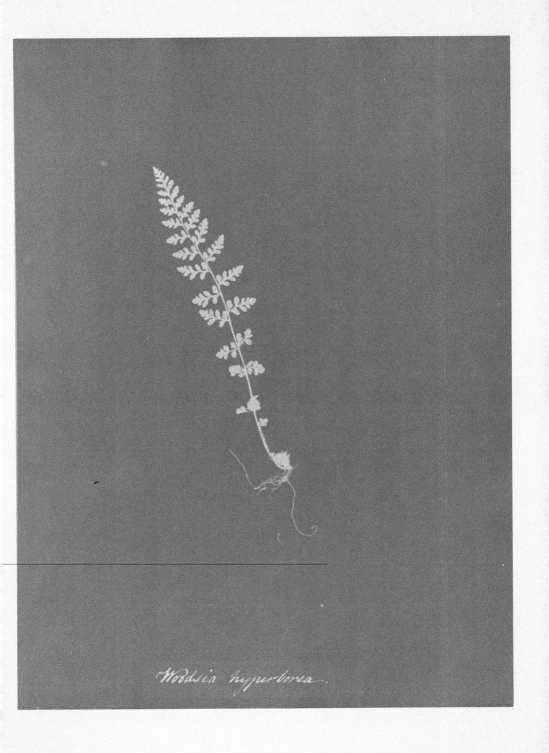

*Woodsia hyperborea.*

PLATE 2

Woodsia hyperborea

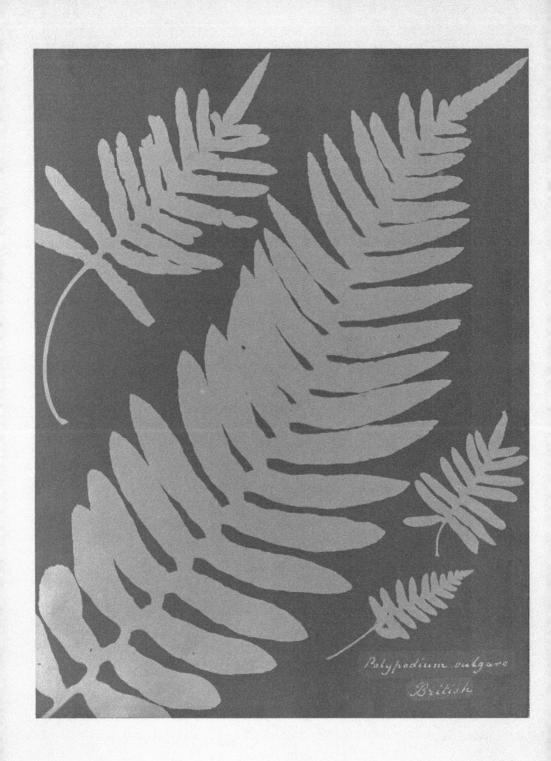

Polypodium vulgare
British

PLATE 3

Polypodium vulgare, British

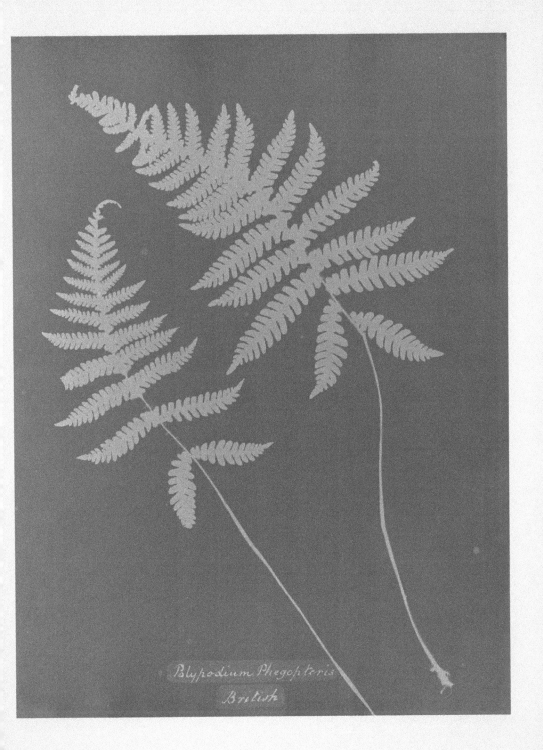

PLATE 4

Polypodium phegopteris, British

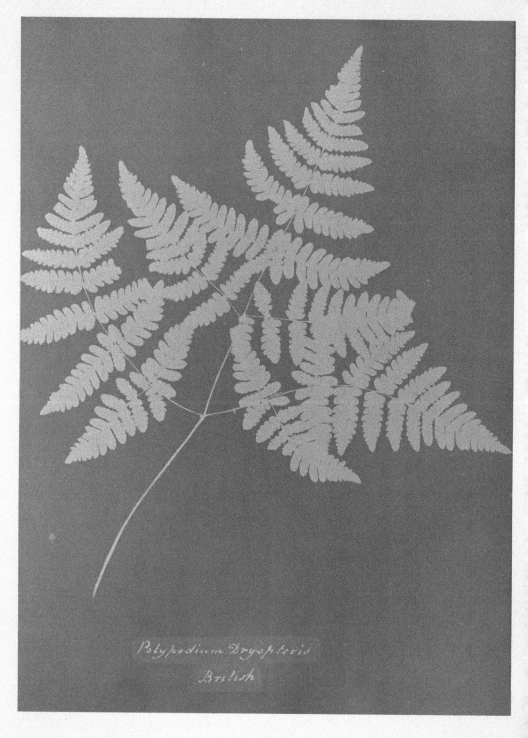

PLATE 5

Polypodium dryopteris, British

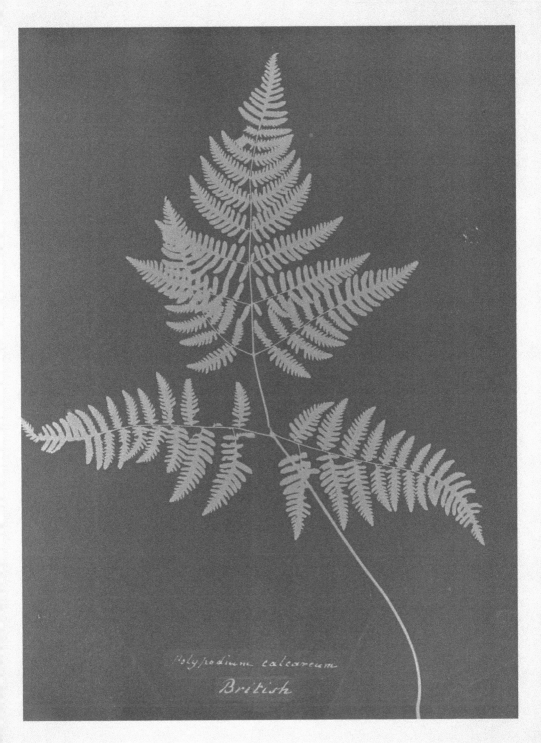

PLATE 6

Polypodium calcareum, British

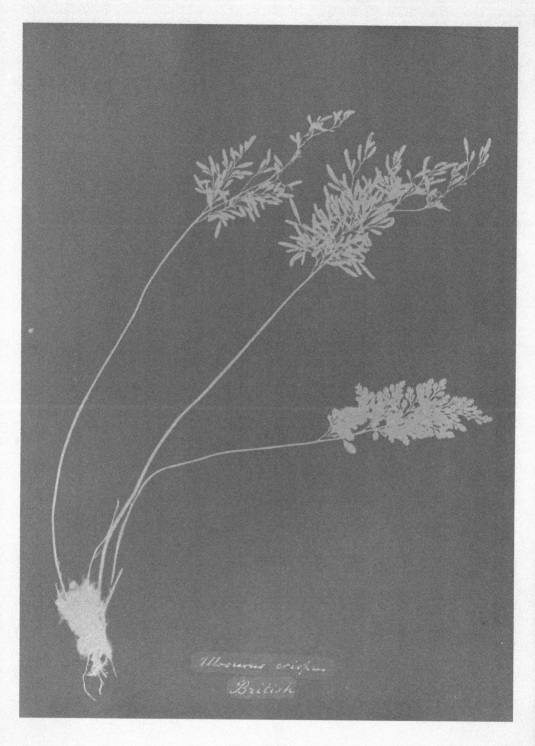

PLATE 7

Allosorus crispus, British

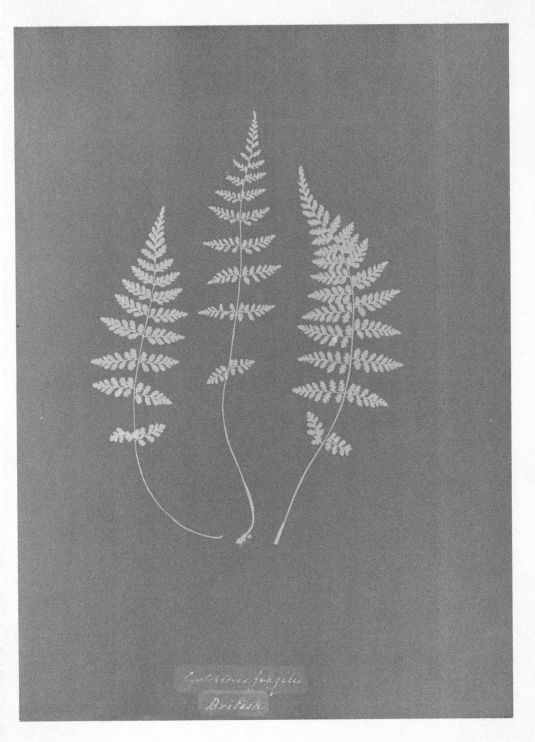

PLATE 8

Cystopteris fragilis, British

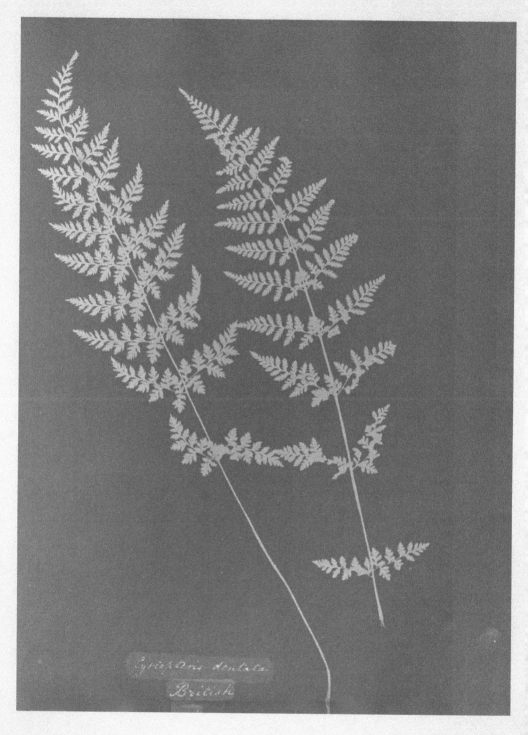

PLATE 9

Cystopteris dentata, British

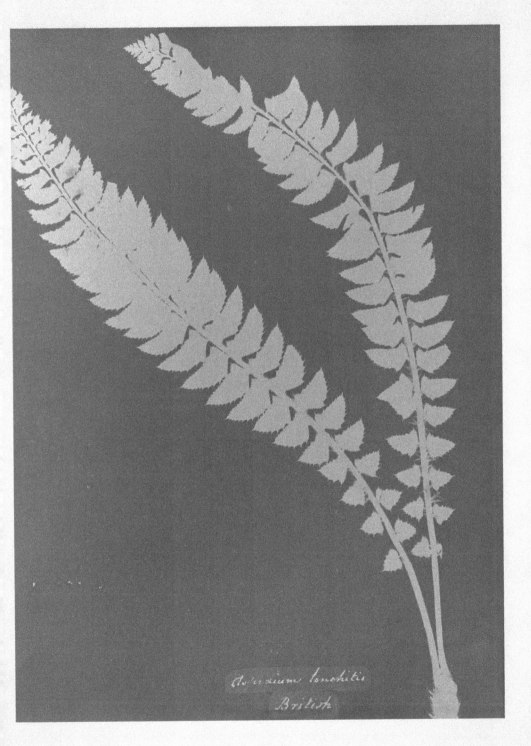

PLATE 10

Asplenium lonchitis, British

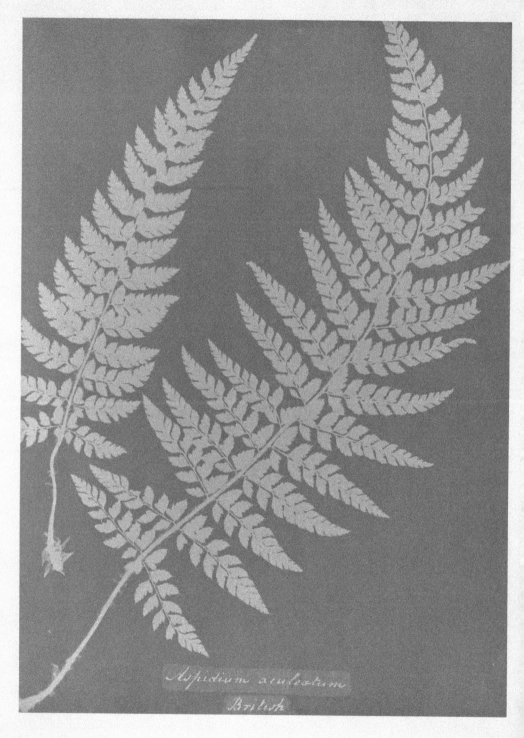

PLATE 11

Aspidium aculeatum, British

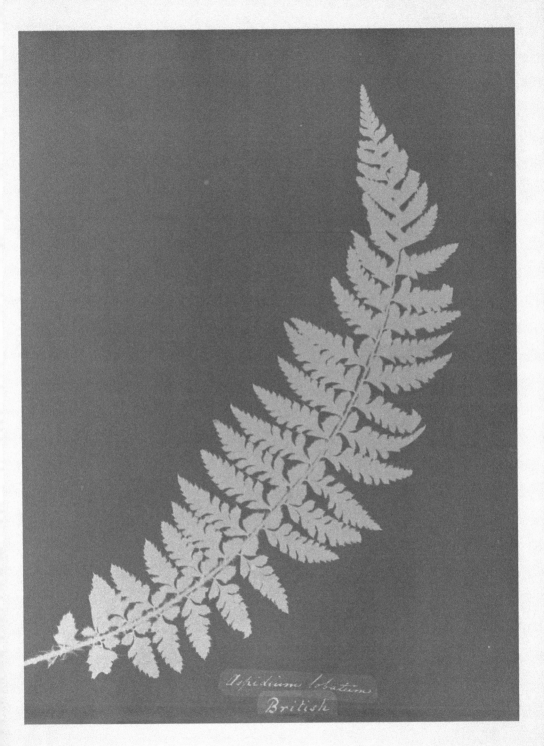

PLATE 12

Aspidium lobatum, British

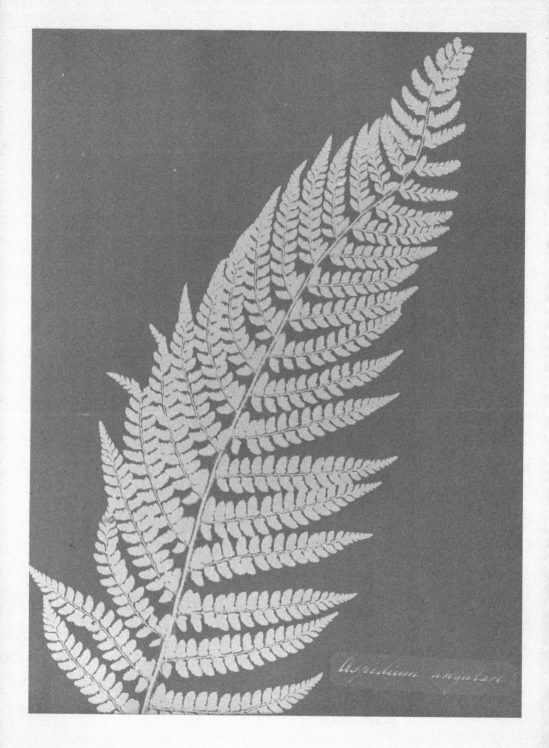

PLATE 13

Aspidium angulare

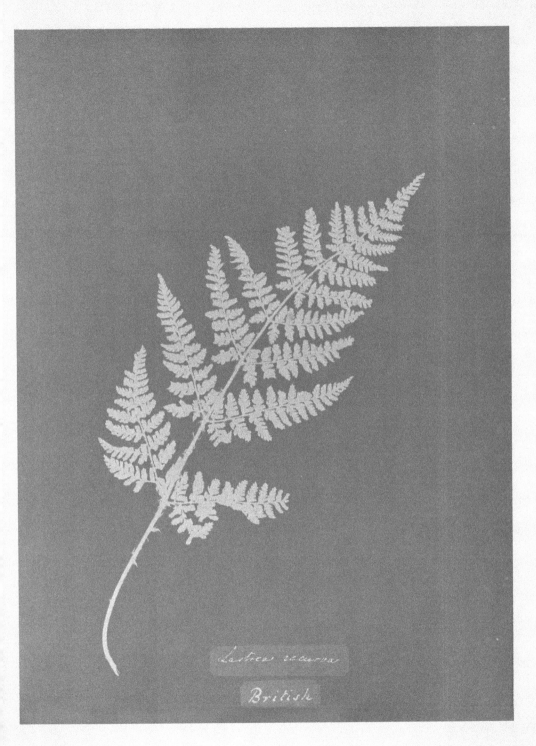

PLATE 14

Lastrea recurva, British

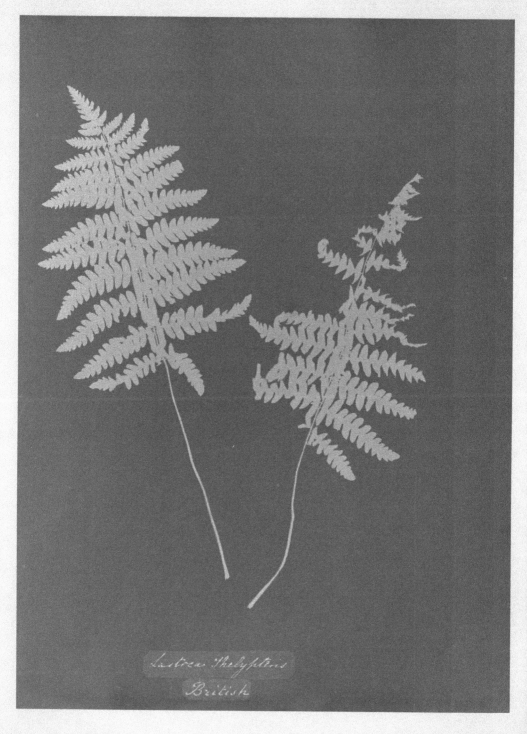

*Lastrea thelypteris*
*British*

PLATE 15

Lastrea thelypteris, British

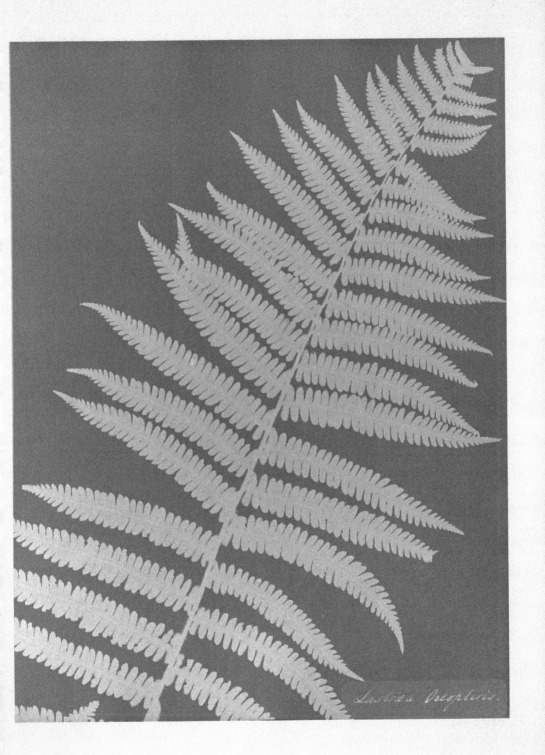

PLATE 16

Lastrea oreopteris

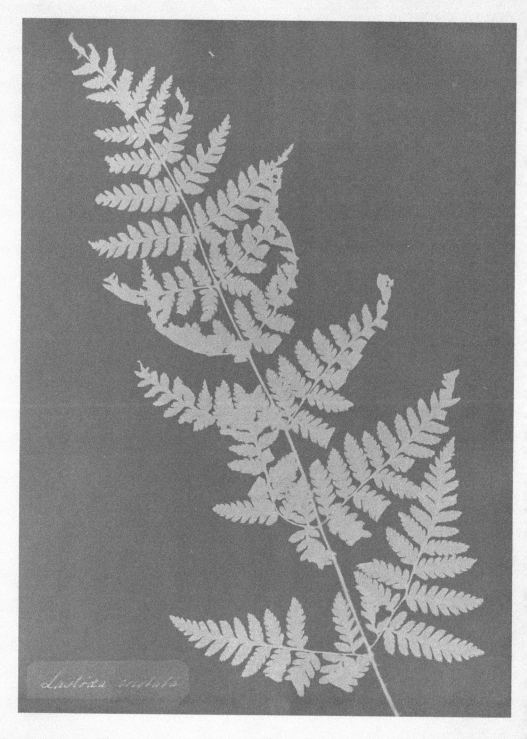

PLATE 17

Lastrea cristata

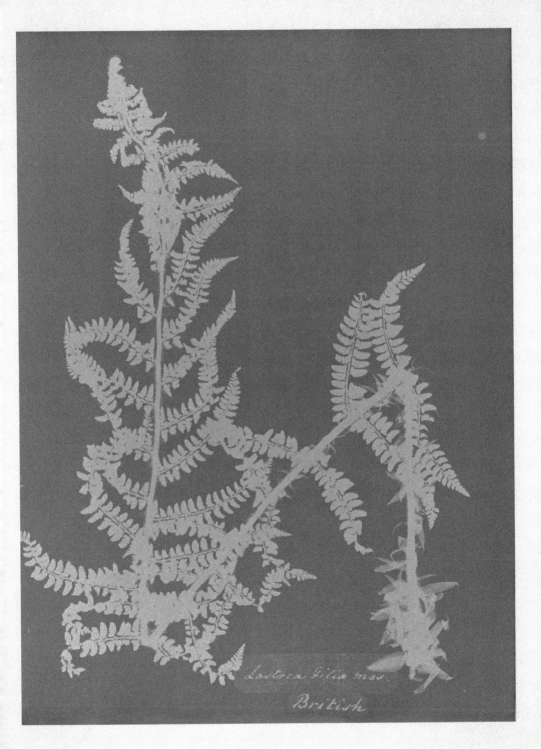

PLATE 18

Lastrea filix mas, British

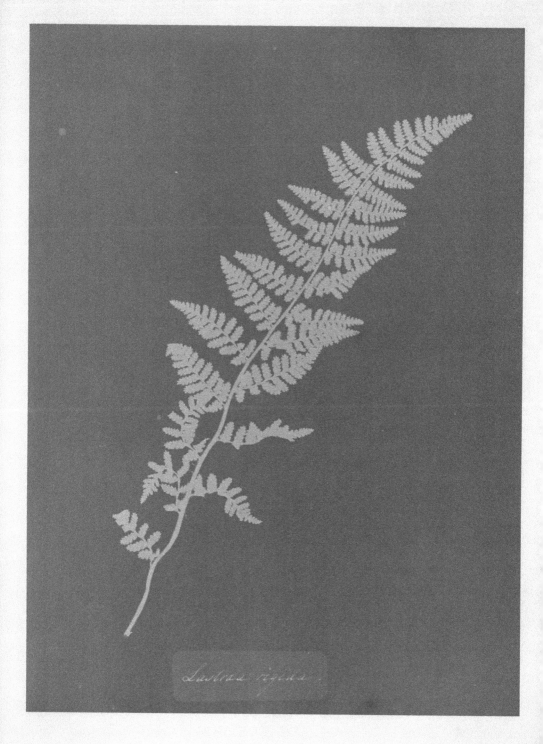

PLATE 19

Lastrea rigida

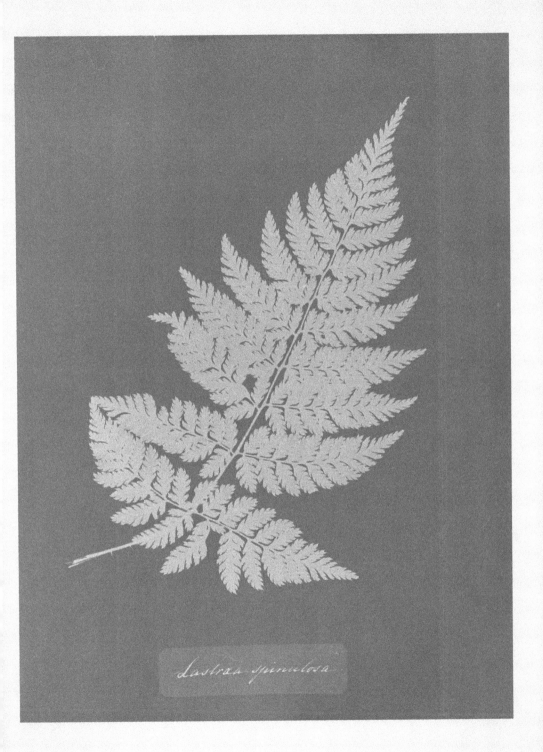

PLATE 20

Lastrea spinulosa

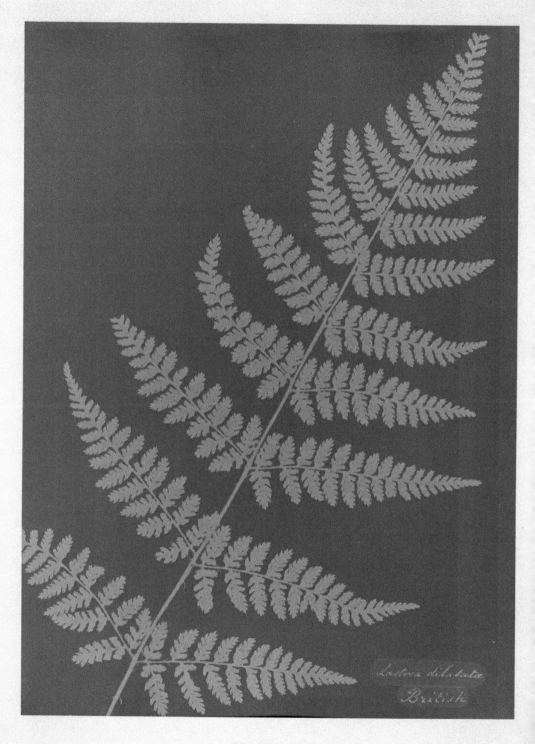

PLATE 21

Lastrea dilatato, British

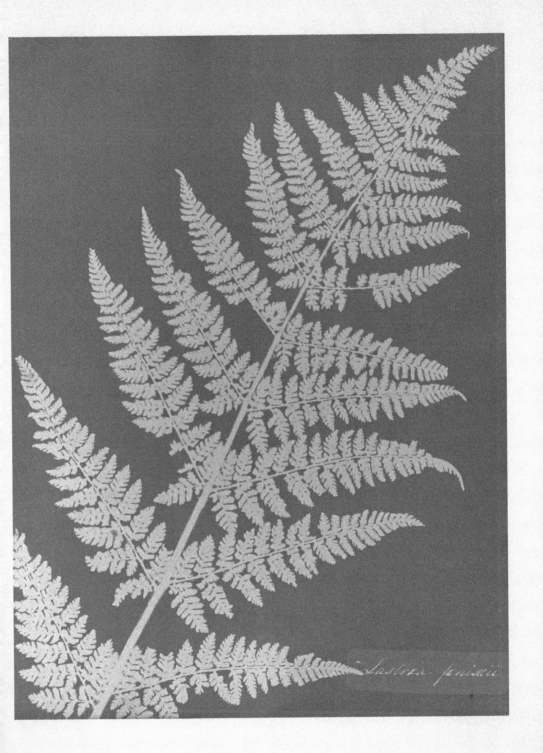

PLATE 22

**Lastrea focnisecii**

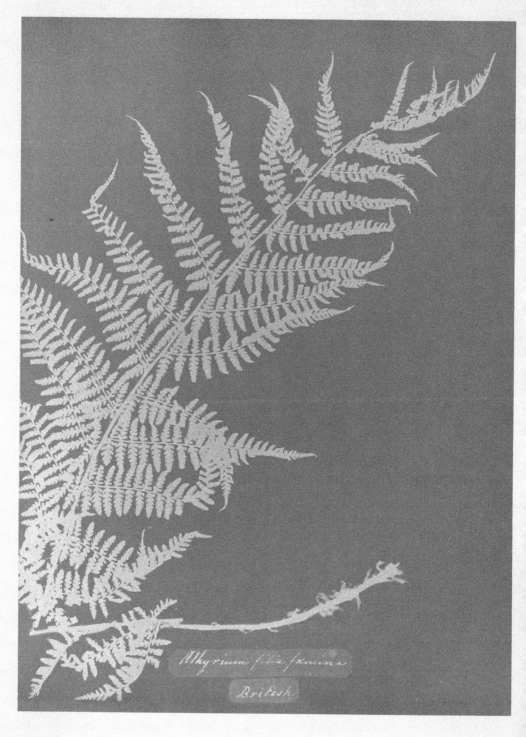

PLATE 23

Athyrium filix femina

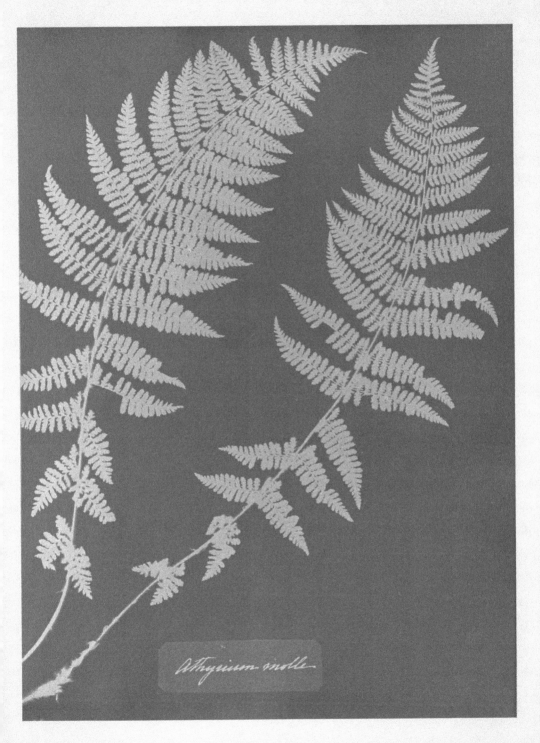

*Athyrium molle*

PLATE 24

Athyrium molle

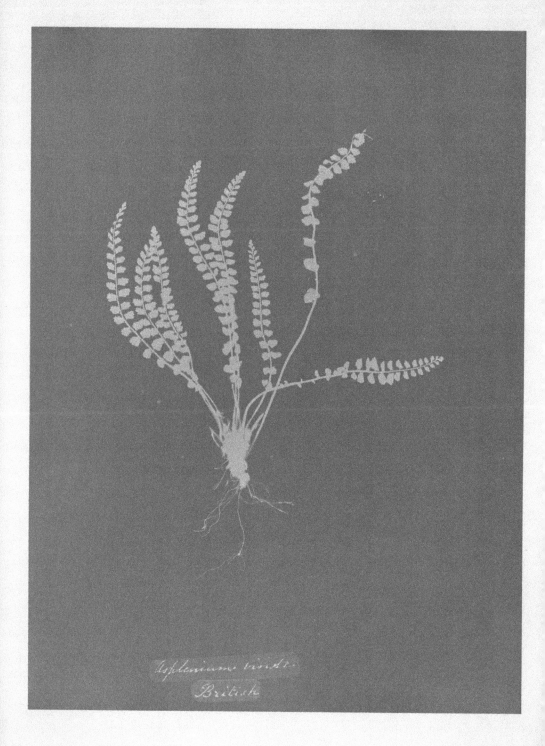

PLATE 25

Asplenium viride, British

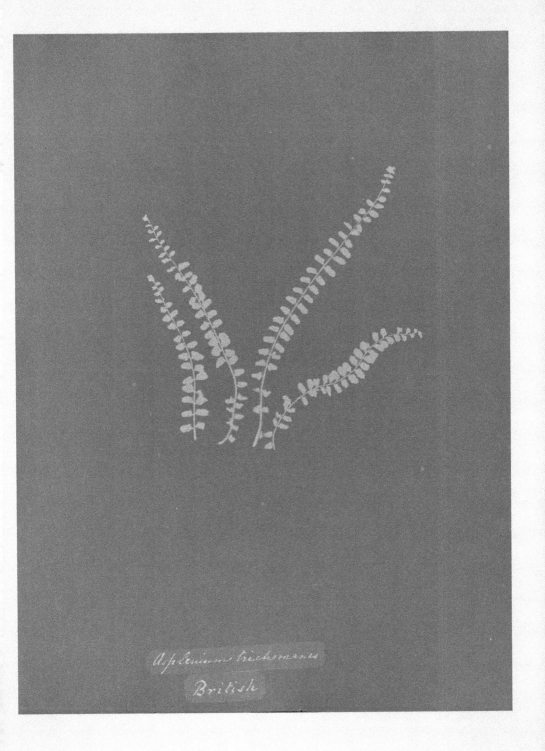

PLATE 26

Asplenium trichomanes, British

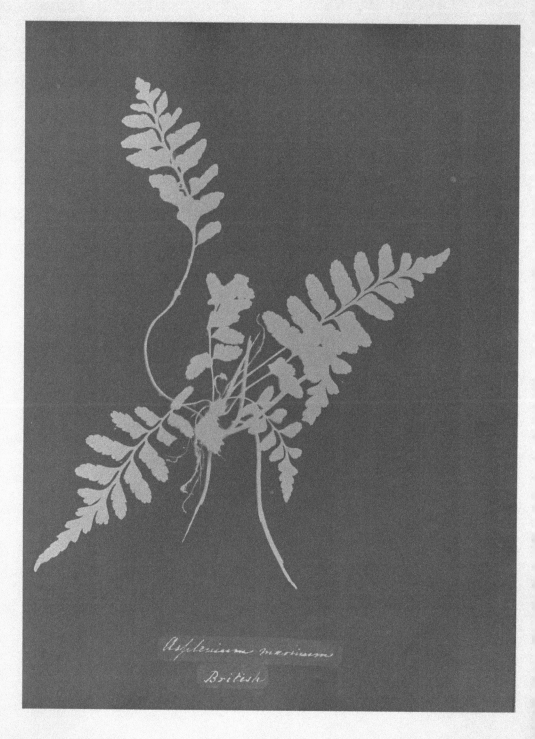

PLATE 27

Asplenium marinum, British

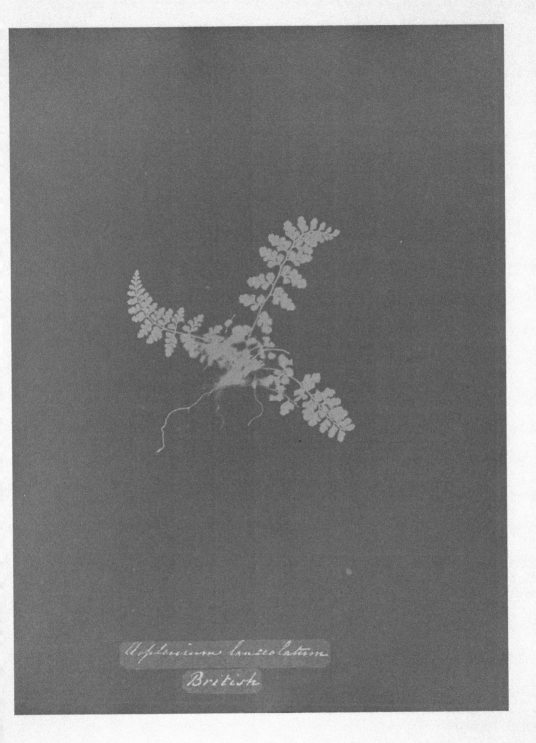

PLATE 28

Asplenium lanceolatum, British

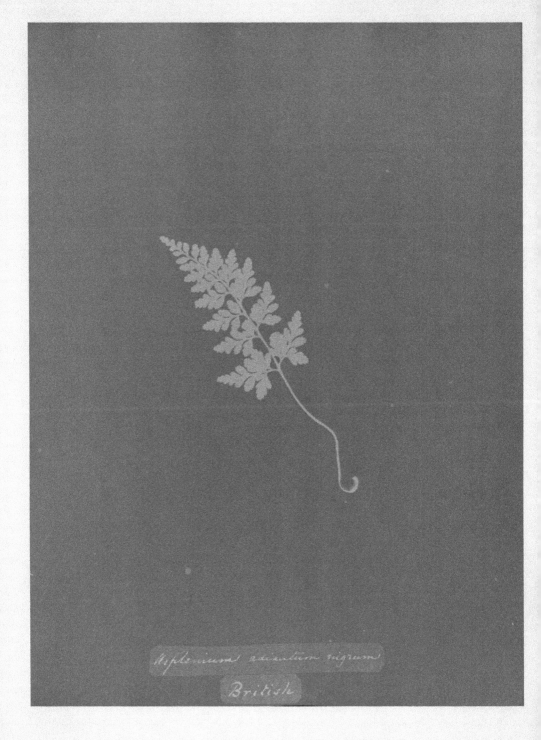

PLATE 29

Asplenium adiantum nigrum, British

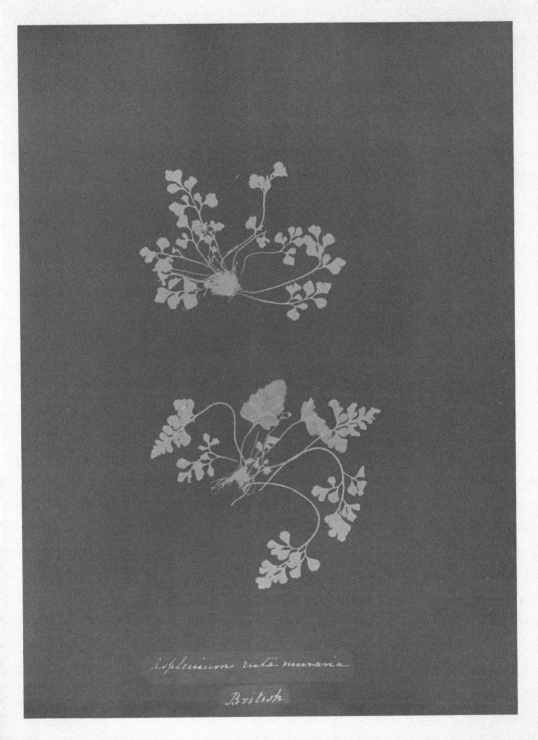

PLATE 30

Asplenium ruta muraria, British

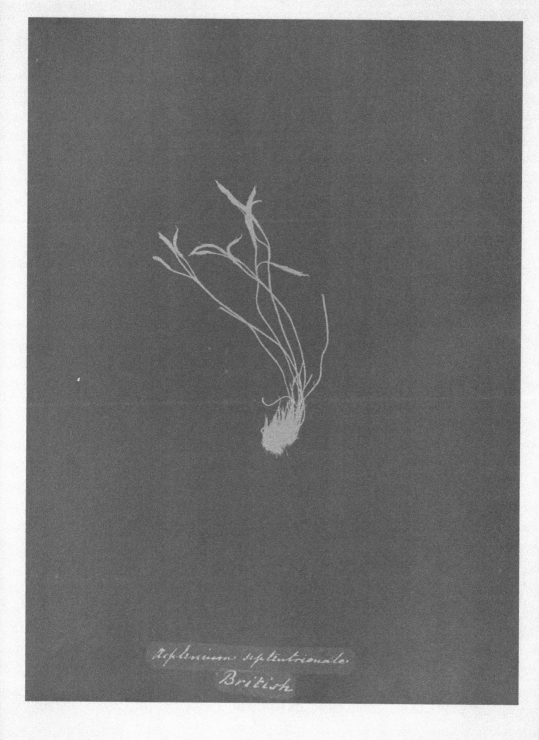

PLATE 31

Asplenium septentrionale, British

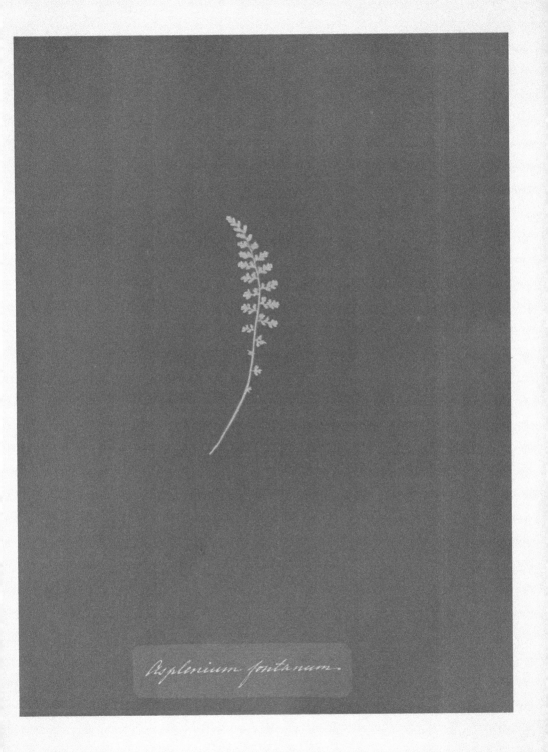

PLATE 32

Asplenium fontanum

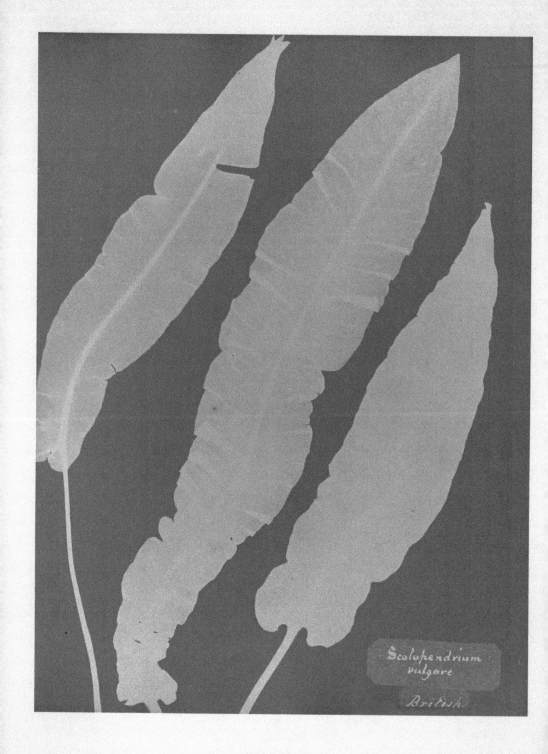

PLATE 33

Scolopendrium vulgare, British

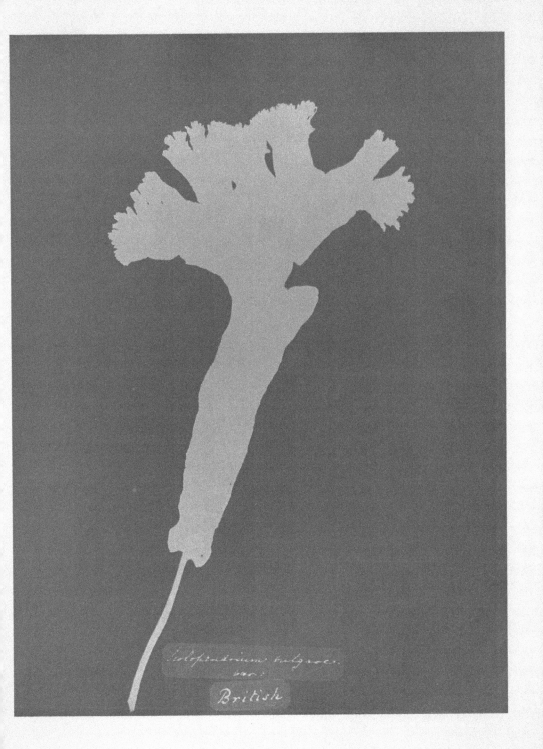

PLATE 34

Scolopendrium vulgare [illeg.], British

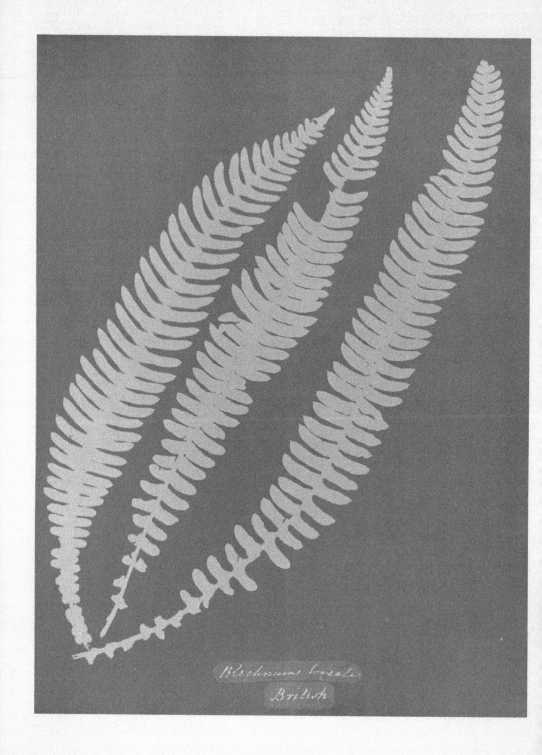

PLATE 35

Blechnum boreale, British

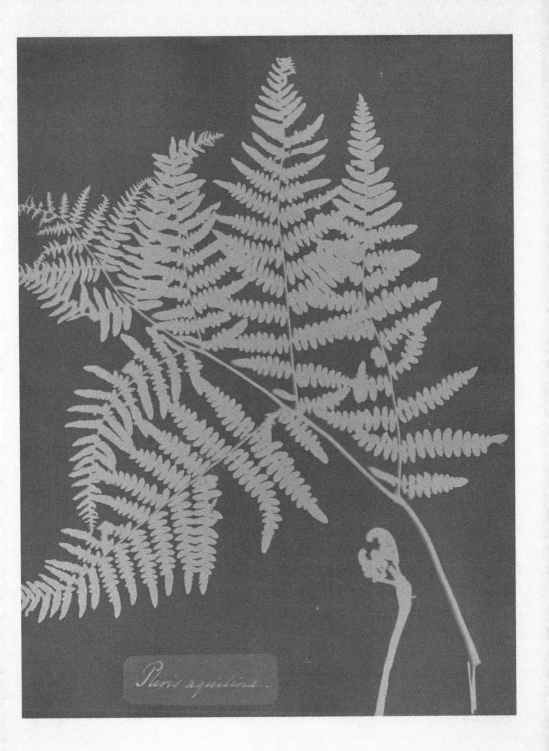

PLATE 36

*Pteris aquilina*

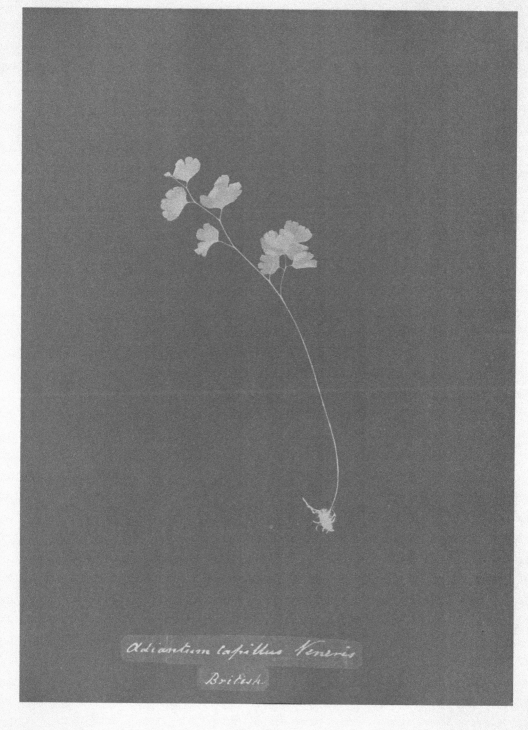

Adiantum capillus Veneris

British

PLATE 37

Adiantum capillus veneris, British

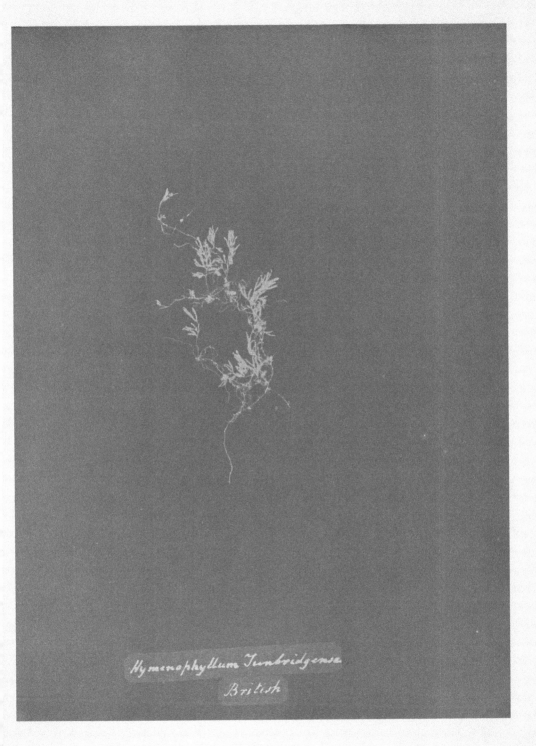

PLATE 38

Hymenophyllum tunbridgense, British

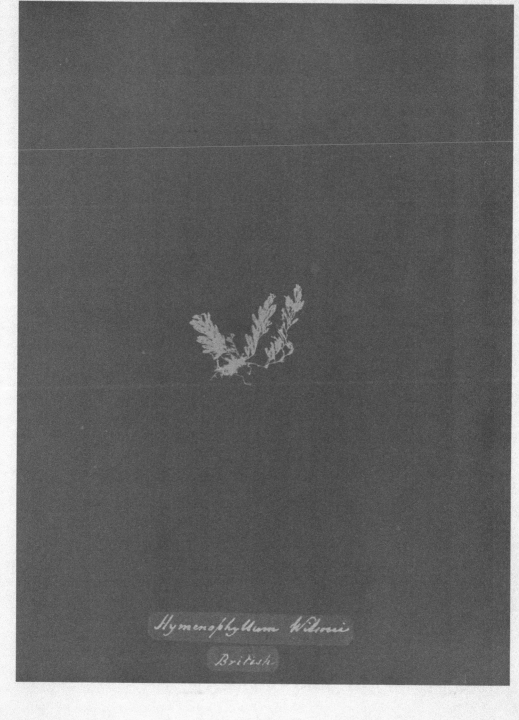

PLATE 39

Hymenophyllum wilsonii, British

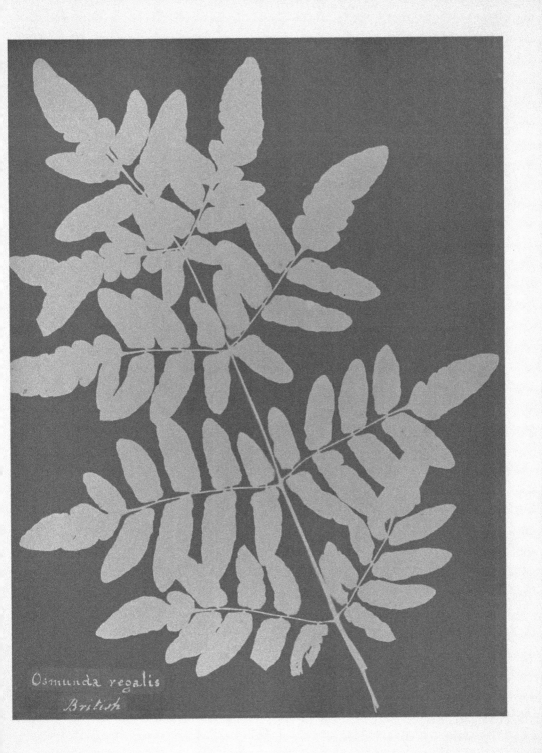

Osmunda regalis
British

PLATE 40

Osmunda regalis, British

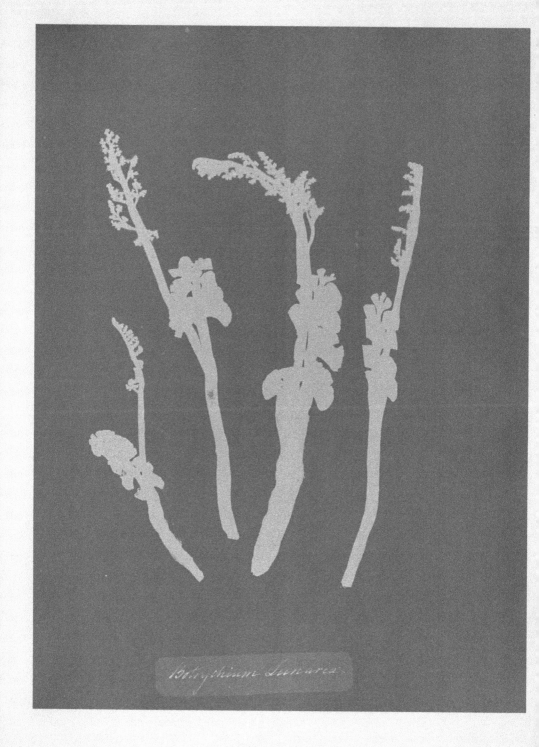

*Botrychium Lunaria*

PLATE 41

Botrychium lunaria

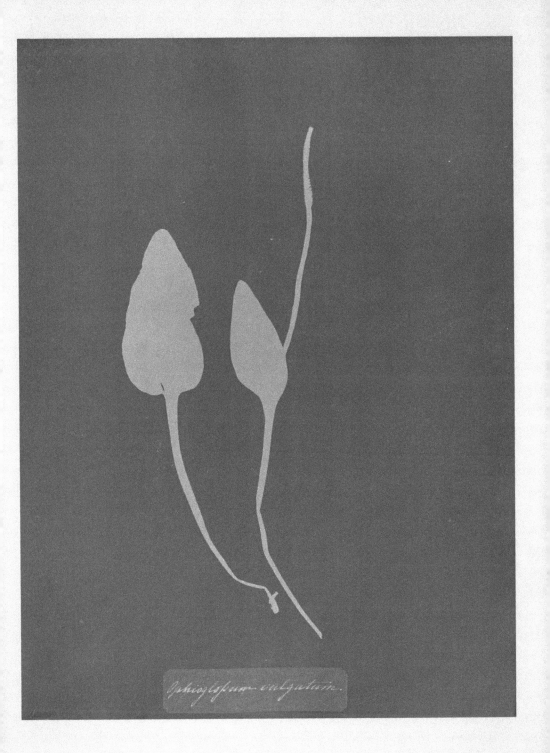

PLATE 42

Ophioglossum vulgatum

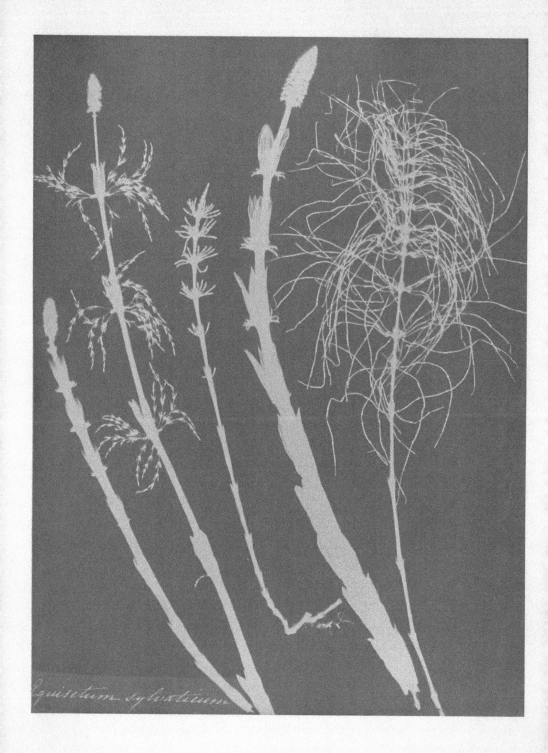

*Equisetum sylvaticum*

PLATE 43

Equisetum sylvaticum

Foreign

Ferns.

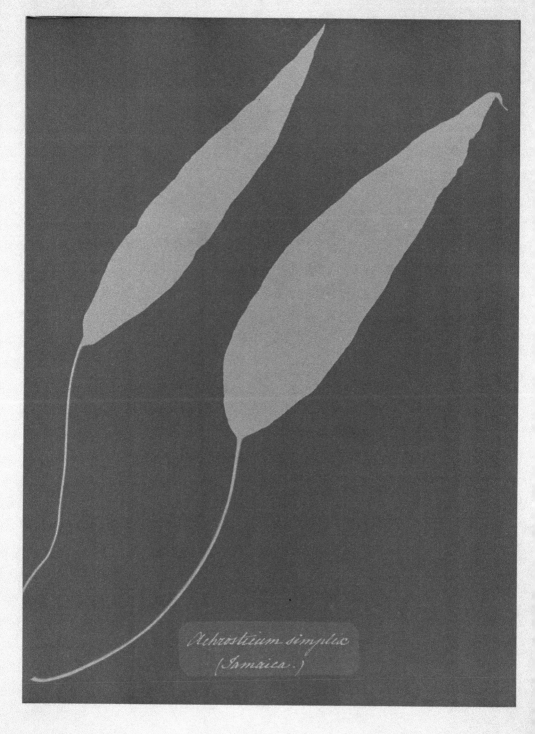

PLATE 44

Achrosticum simplex, Jamaica

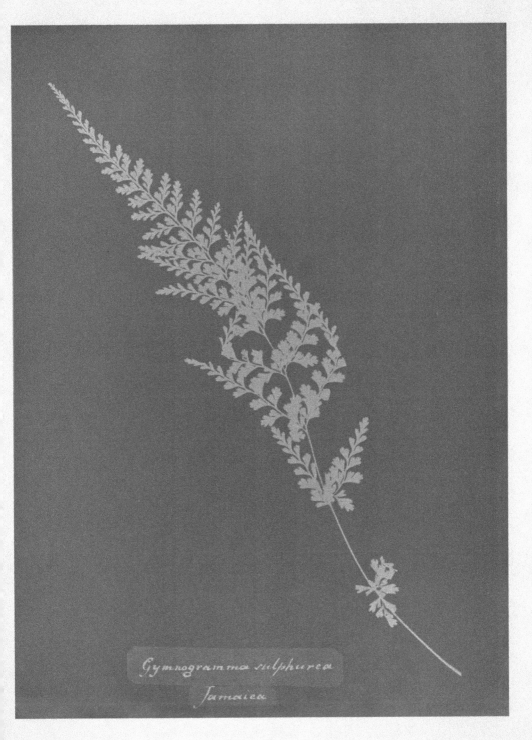

PLATE 45

Gymnogramma sulphurea, Jamaica

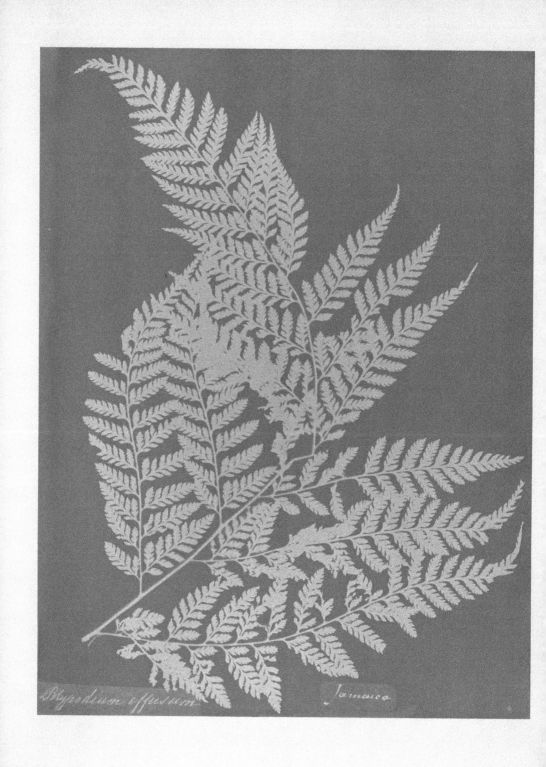

PLATE 46

Polypodium effusum, Jamaica

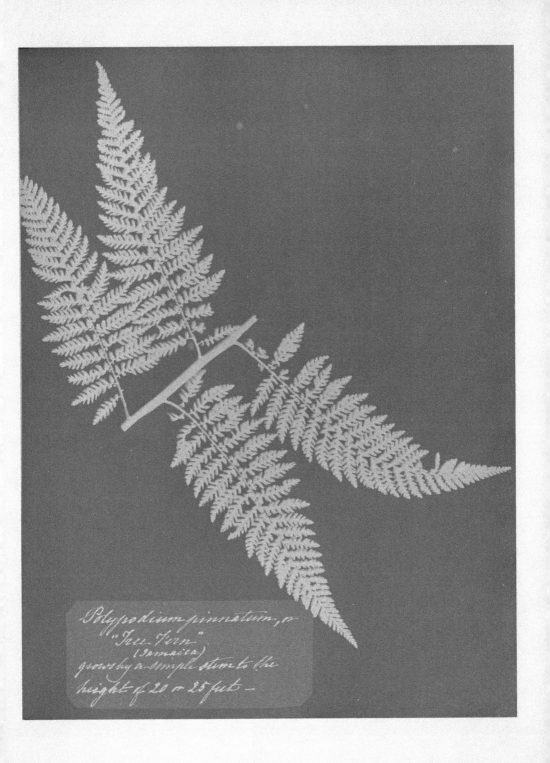

PLATE 47

Polypodium pinnatum, Jamaica

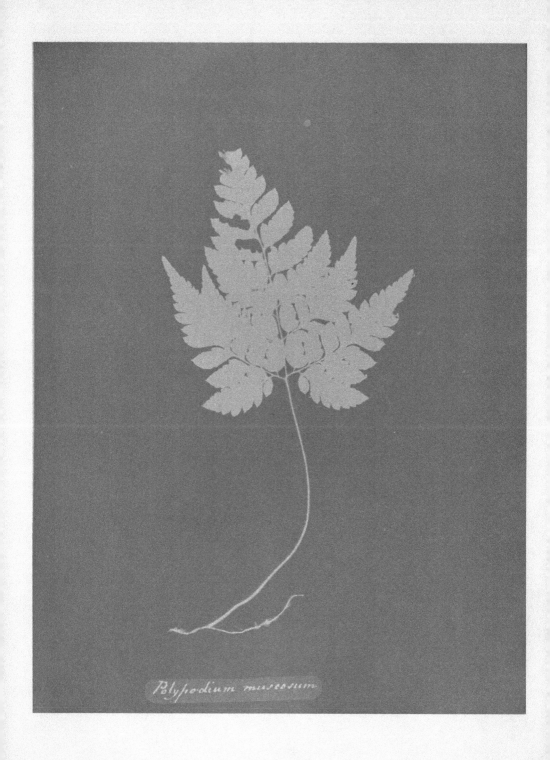

*Polypodium muscosum*

PLATE 48

Polypodium muscosum

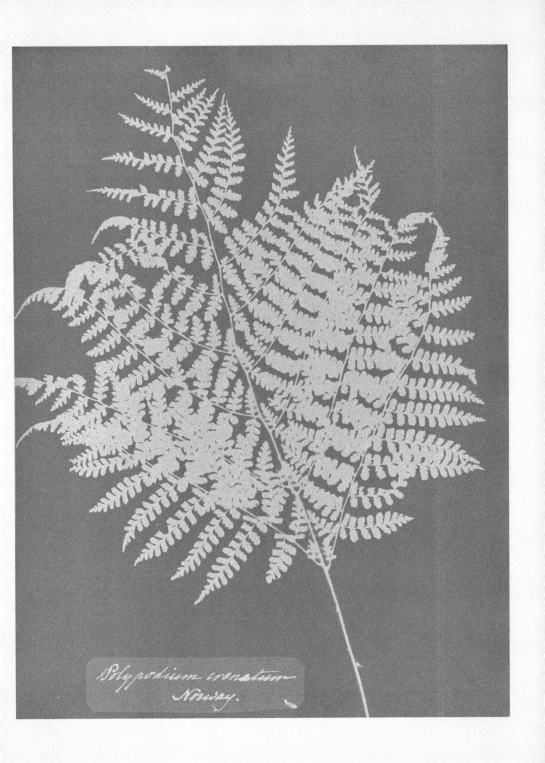

*Polypodium crenatum*
*Norway.*

PLATE 49

Polypodium crenatum, Norway

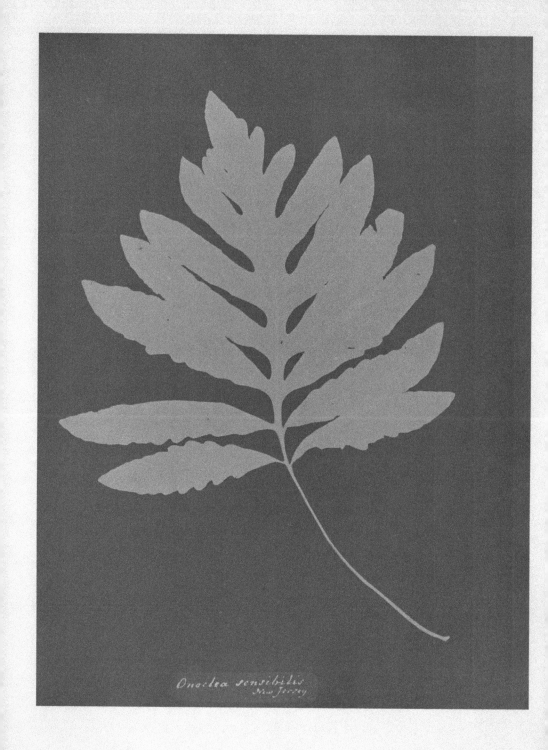

*Onoclea sensibilis*
*New Jersey*

PLATE 50

Onoclea sensibilis, New Jersey

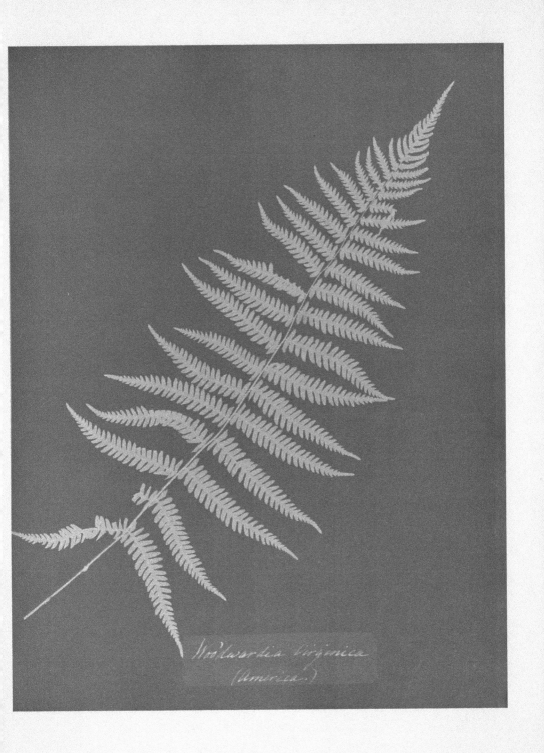

Woodwardia virginica
(America.)

PLATE 51

Woodwardia virginica, America

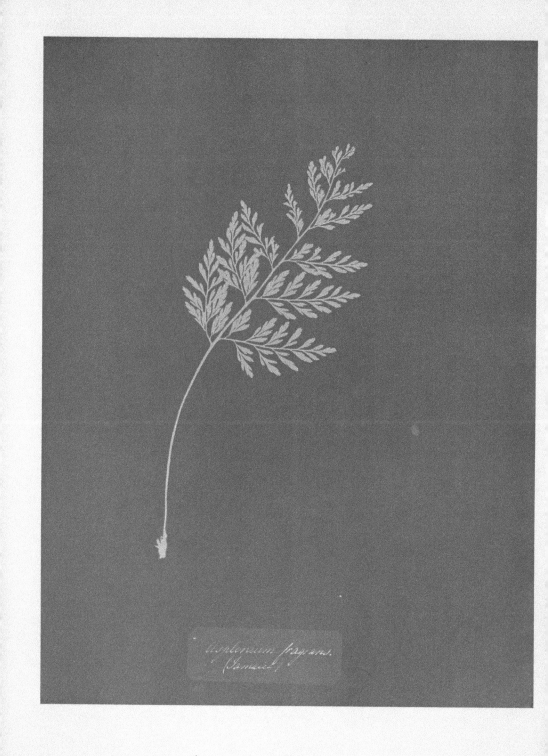

PLATE 52

Asplenium fragrans, Jamaica

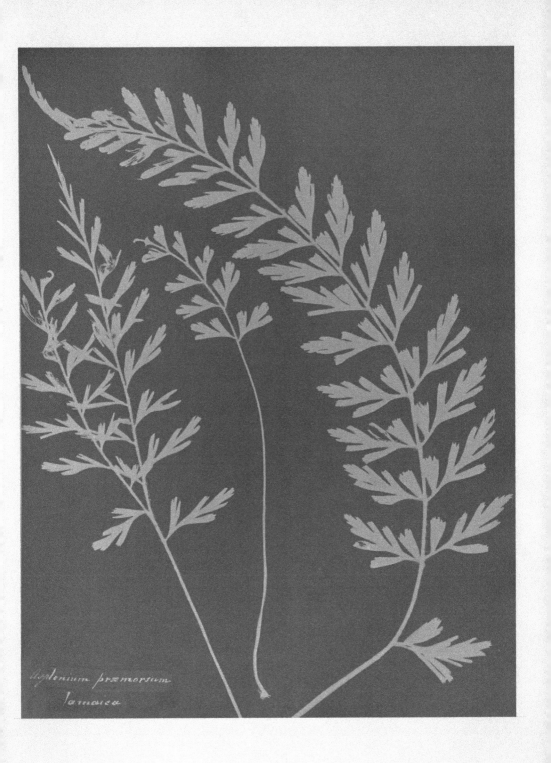

PLATE 53

Asplenium praemorsum, Jamaica

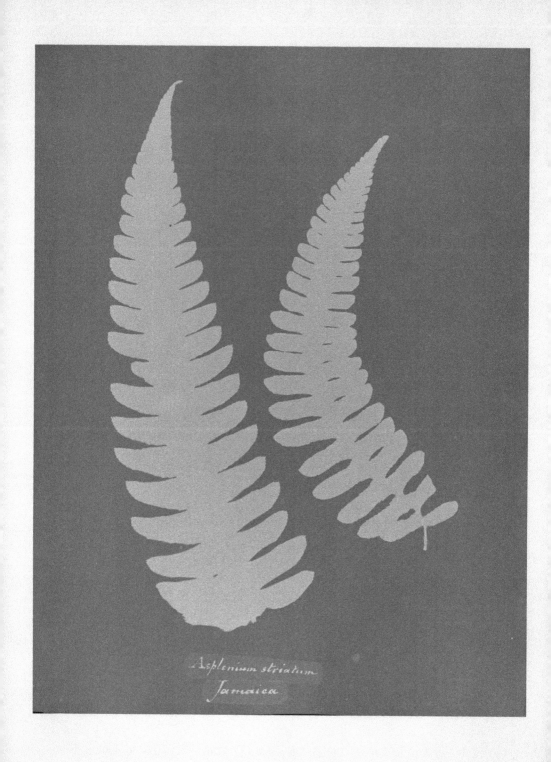

PLATE 54

Asplenium striatum

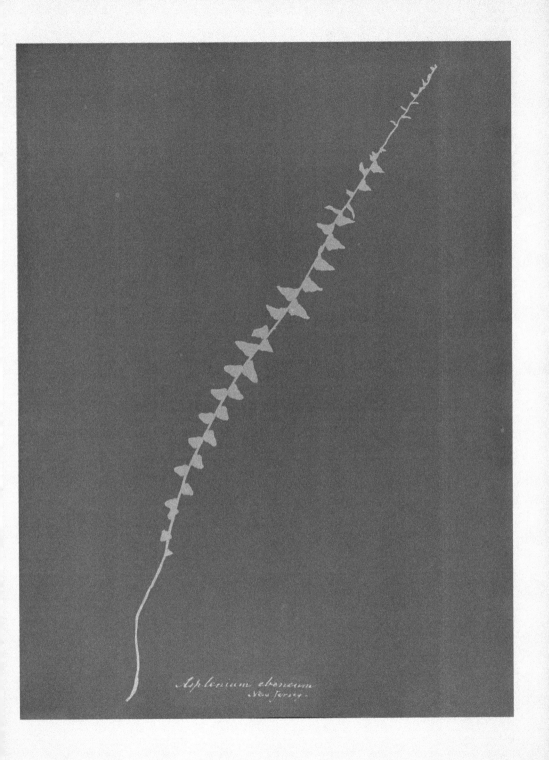

PLATE 55

Asplenium ebenum, New Jersey

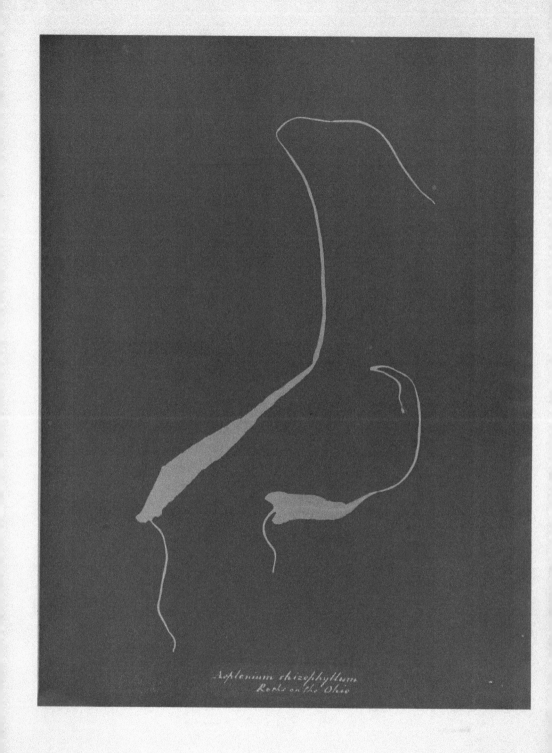

Asplenium rhizophyllum
Rocks on the Ohio

PLATE 56

Asplenium rhizophyllum

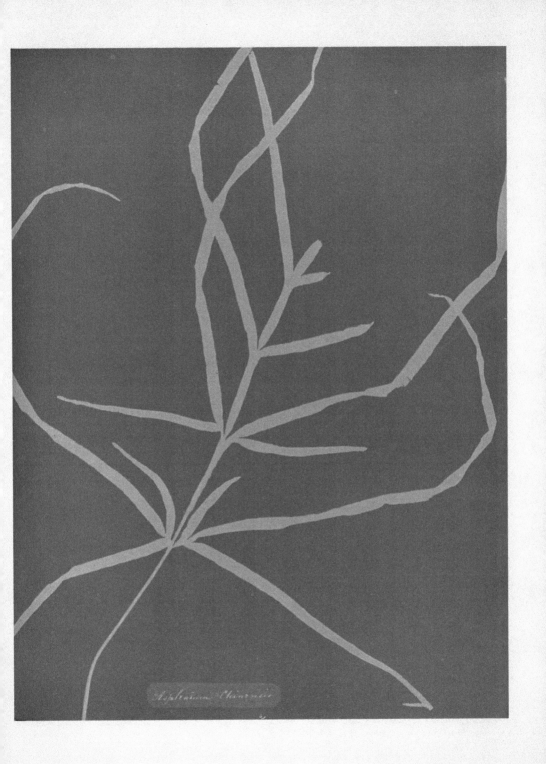

PLATE 57

Asplenium Chinensis

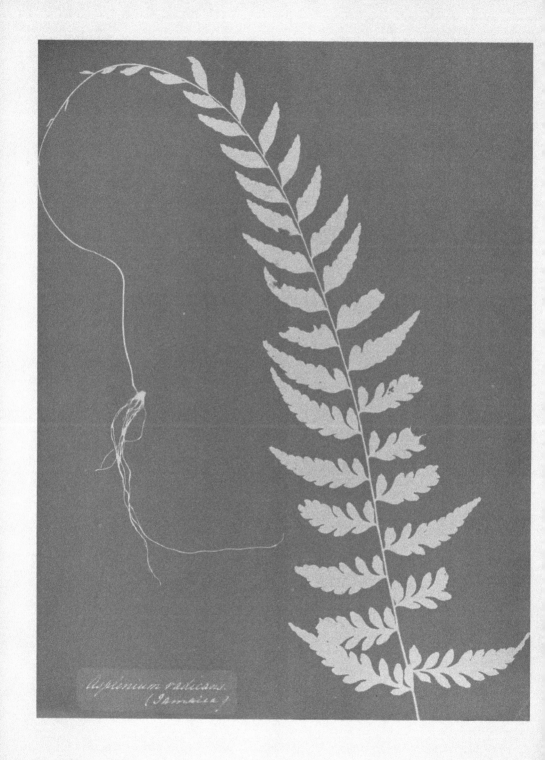

*Asplenium radicans.*
*(Jamaica)*

PLATE 58

Asplenium radicans, Jamaica

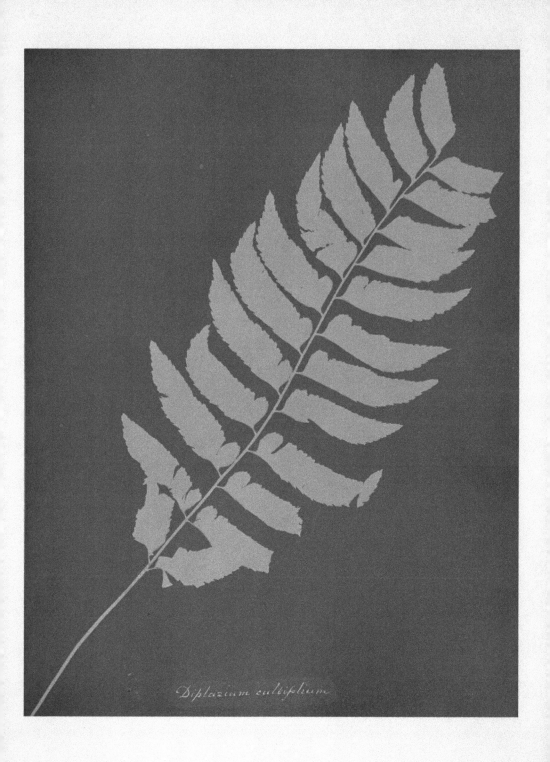

*Diplazium cultifolium*

PLATE 59

Diplazium cultifolium

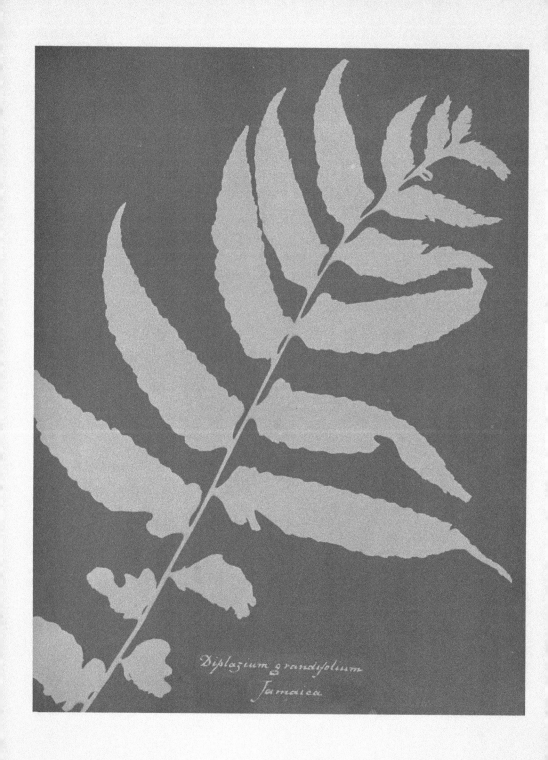

PLATE 60

Diplazium grandifolium, Jamaica

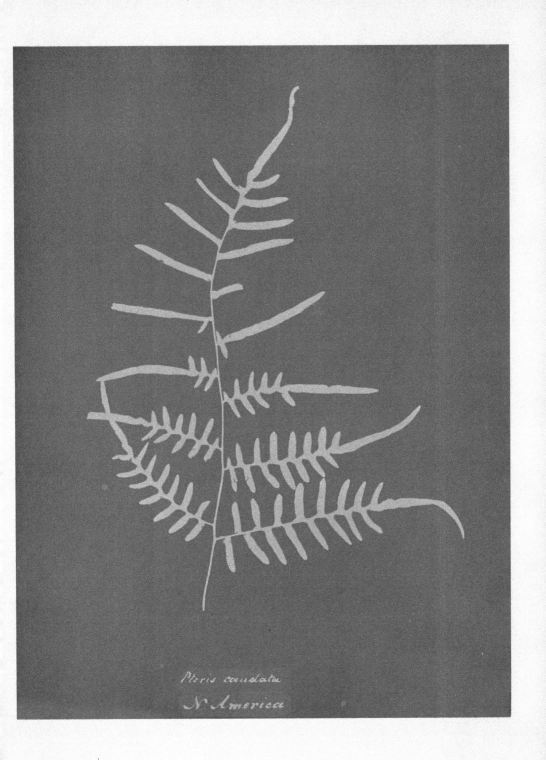

PLATE 61

Pteris caudata, N. America

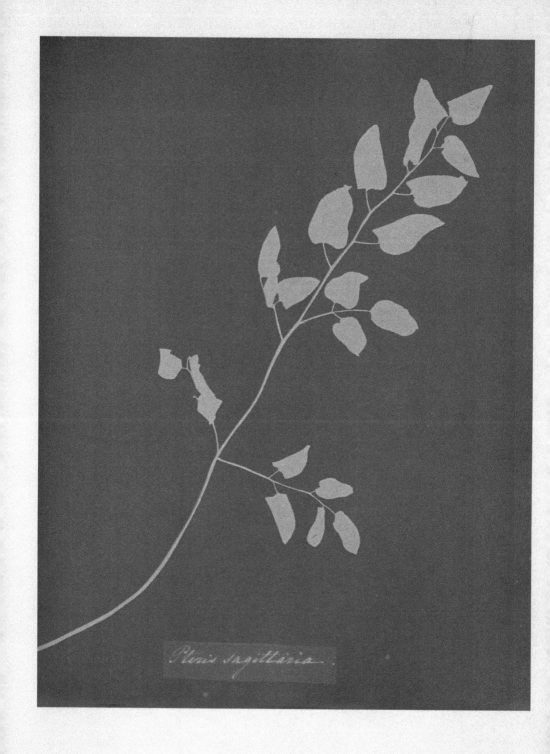

PLATE 62

*Pteris sagittaria*

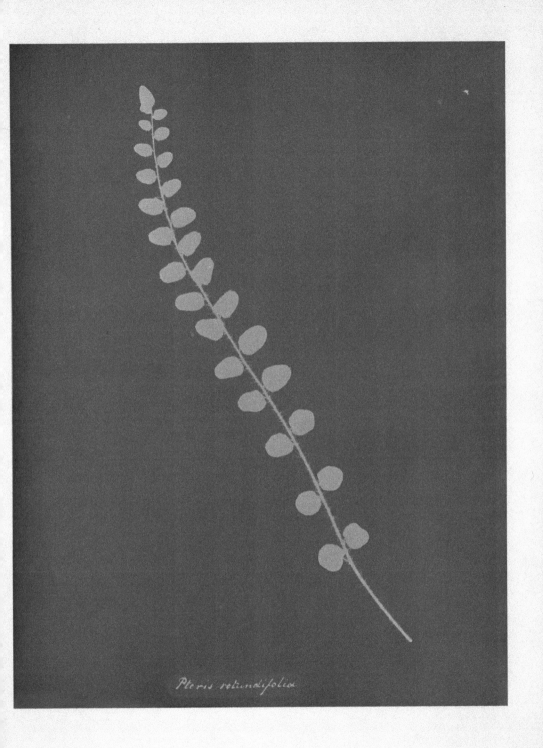

*Pteris rotundifolia*

PLATE 63

Pteris rotundifolia

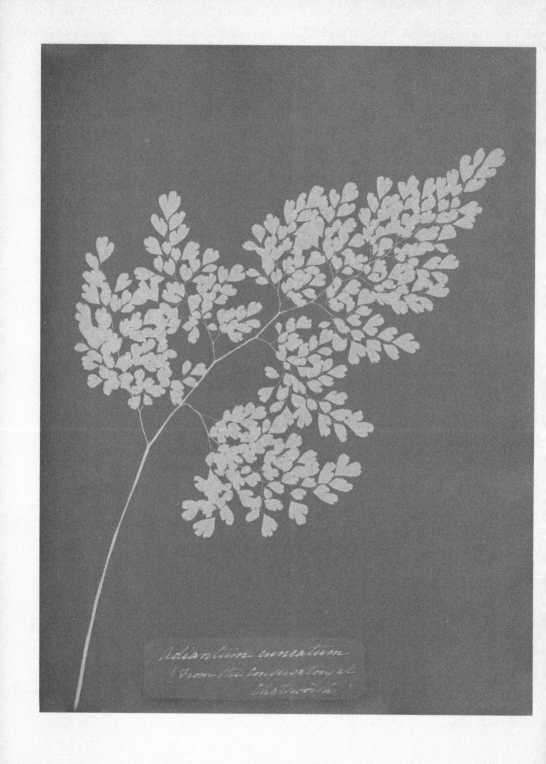

PLATE 64

*Adiantum cuneatum*

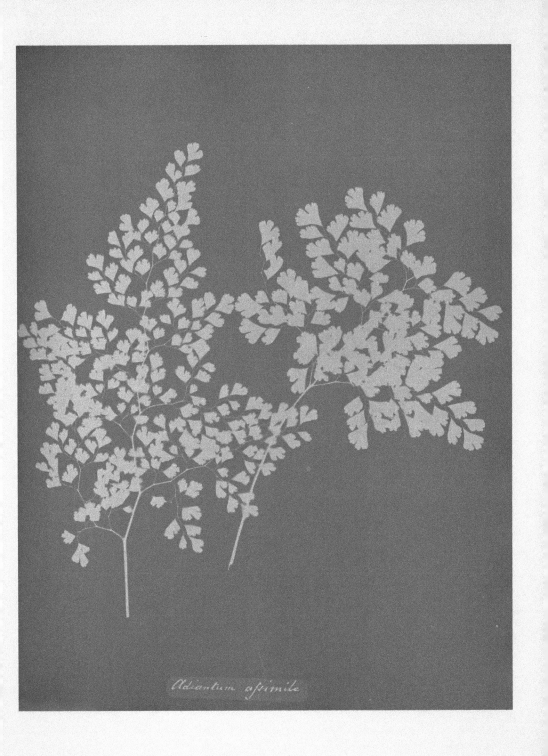

*Adiantum assimile*

PLATE 65

Adiantum assimile

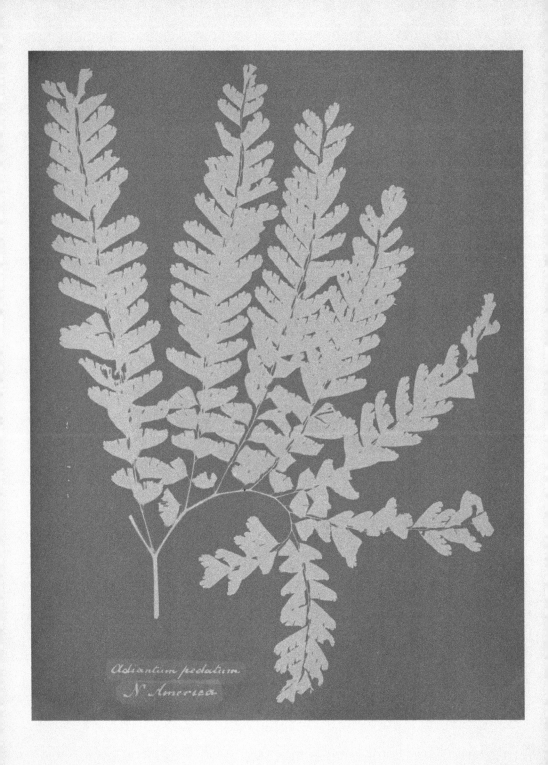

PLATE 66

Adiantum pedatum, N. America

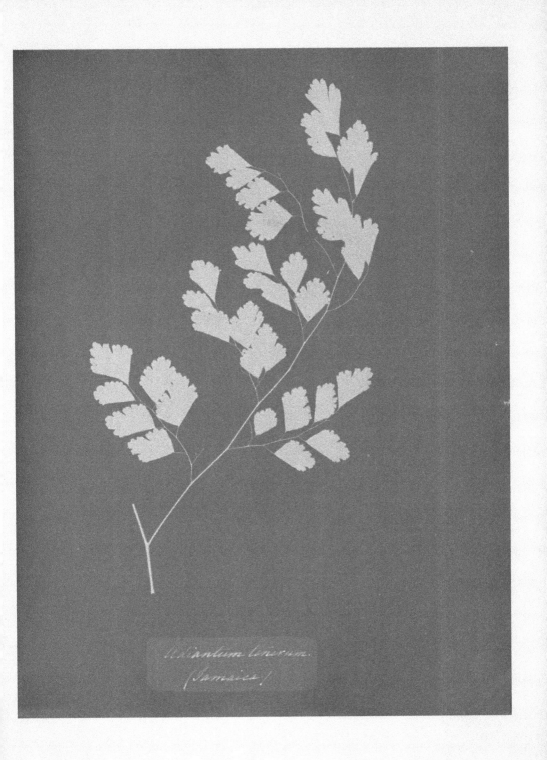

PLATE 67

Adiantum tenerum, Jamaica

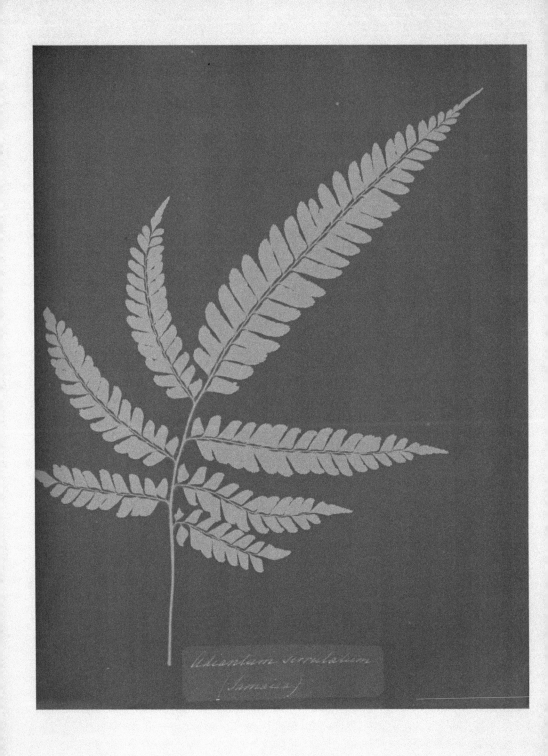

PLATE 68

Adiantum serrulatum, Jamaica

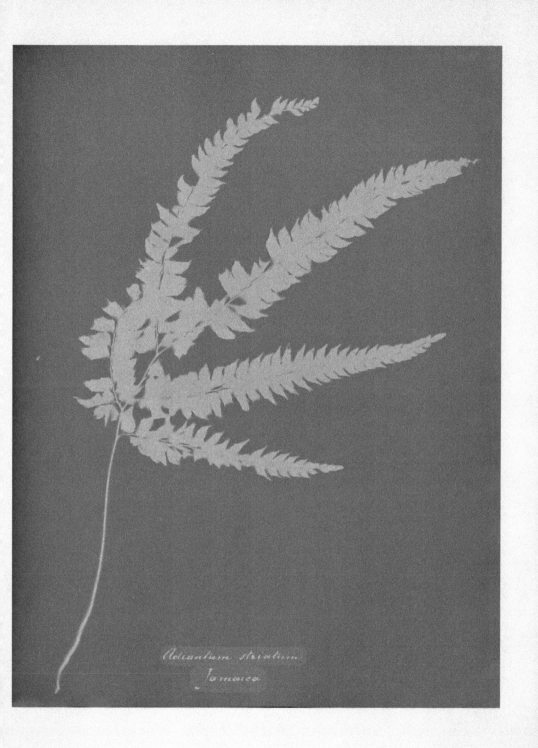

PLATE 69

Adiantum striatum, Jamaica

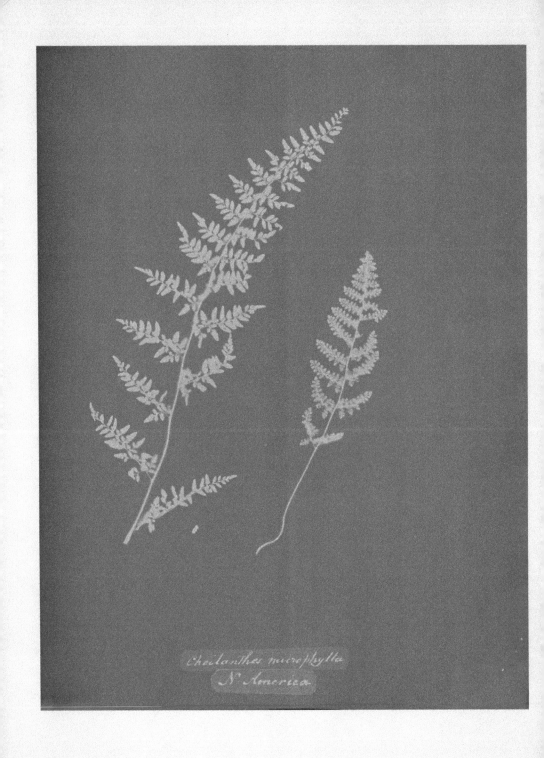

PLATE 70

Cheilanthes microphylla, N. America

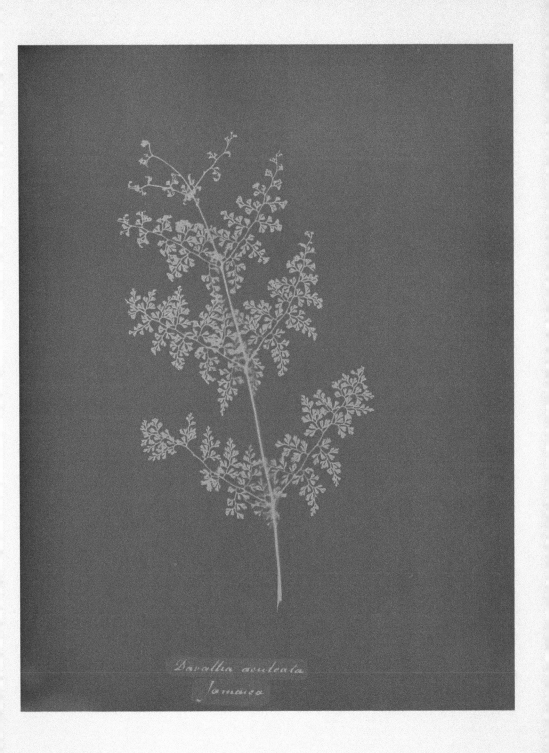

PLATE 71

Davallia aeuleata, Jamaica

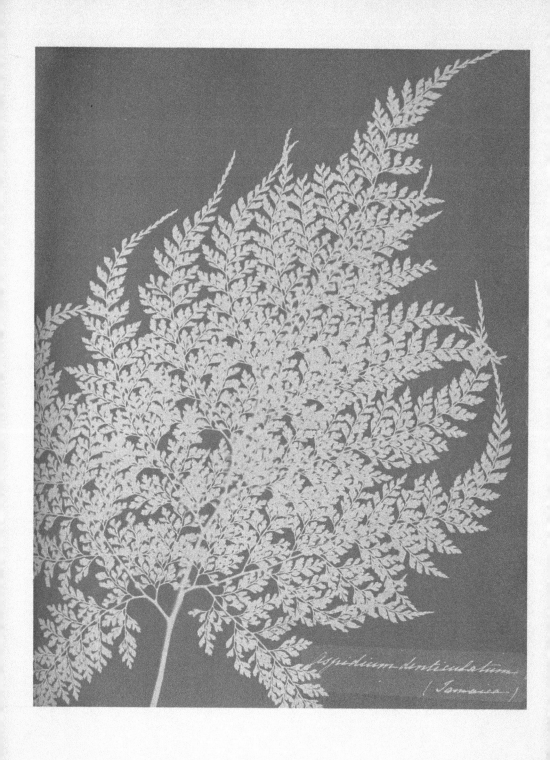

PLATE 72

Aspidium denticulatum, Jamaica

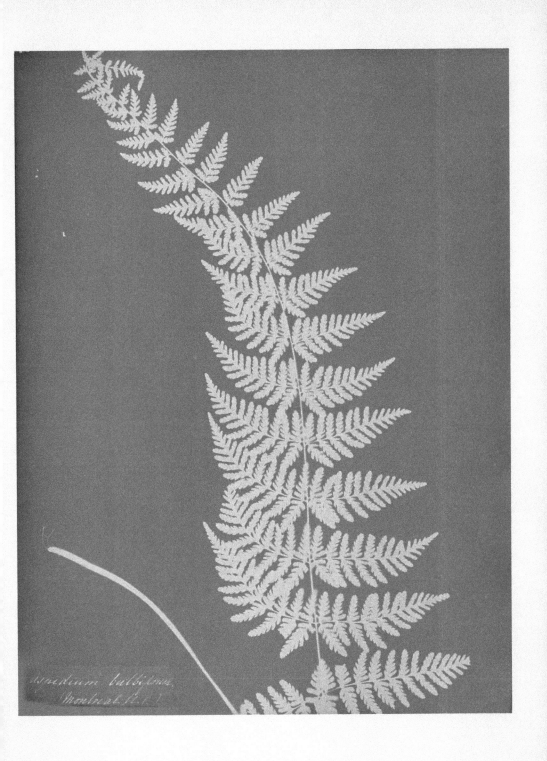

PLATE 73

Aspidium bulbiferum, Montreal

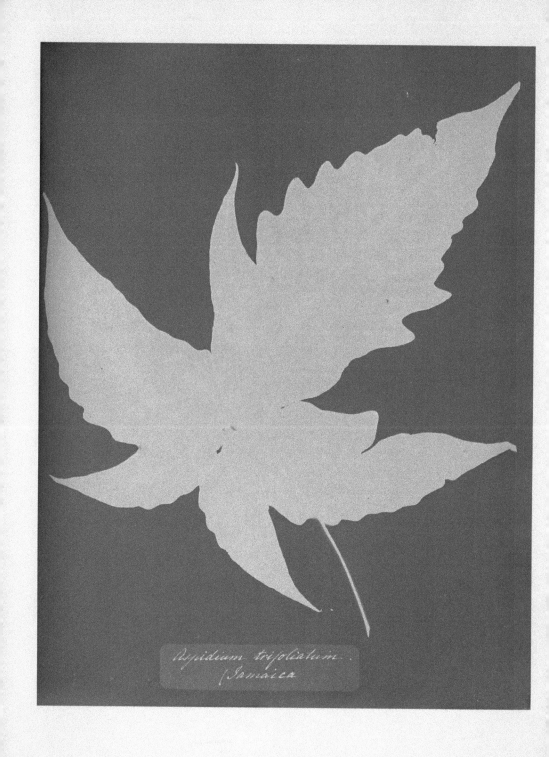

PLATE 74

Aspidium trifoliatum, Jamaica

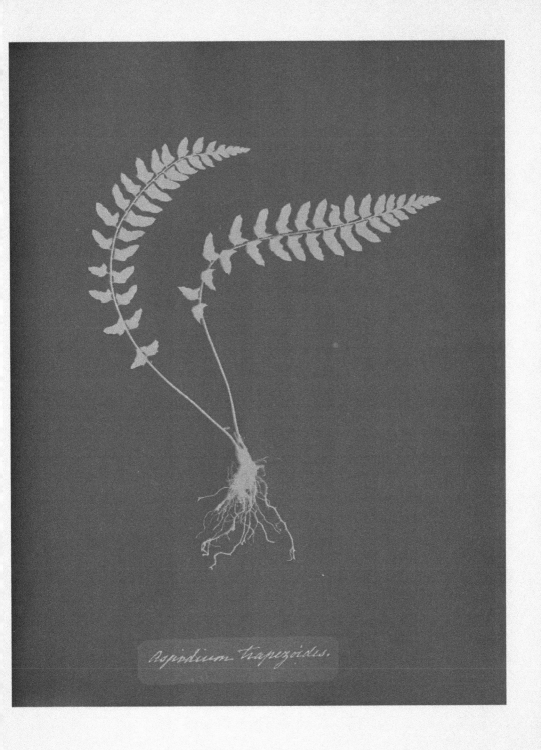

*aspidium trapezoides.*

PLATE 75

Aspidium trapezoides

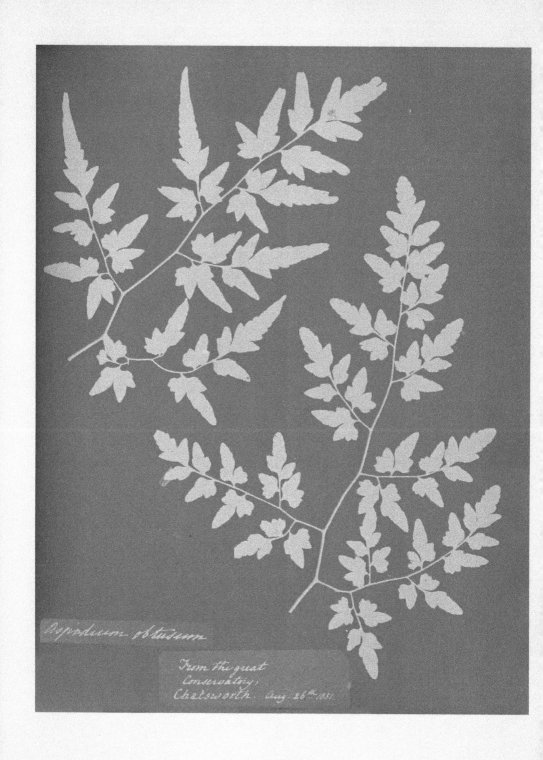

Aspidium obtusium

From the great
Conservatory,
Chatsworth. Aug. 26th 1851.

PLATE 76

Aspidium obtusium

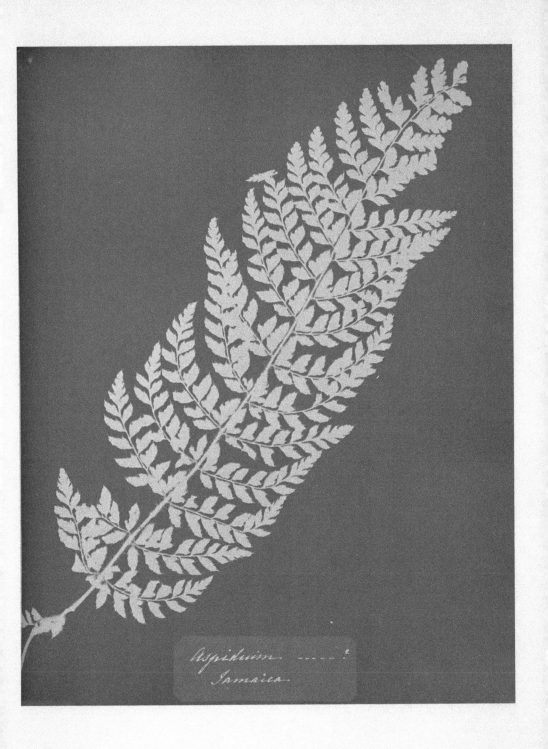

PLATE 77

Aspidium _____ ?, Jamaica

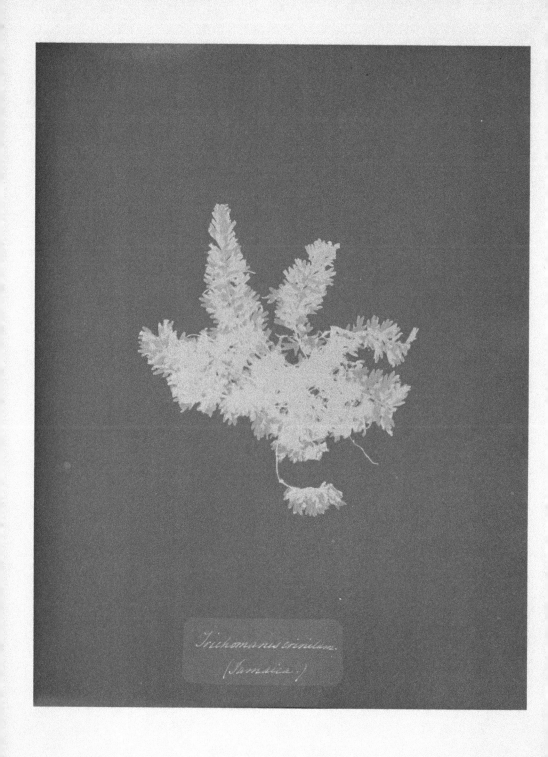

PLATE 78

Trichomones crinitum, Jamaica

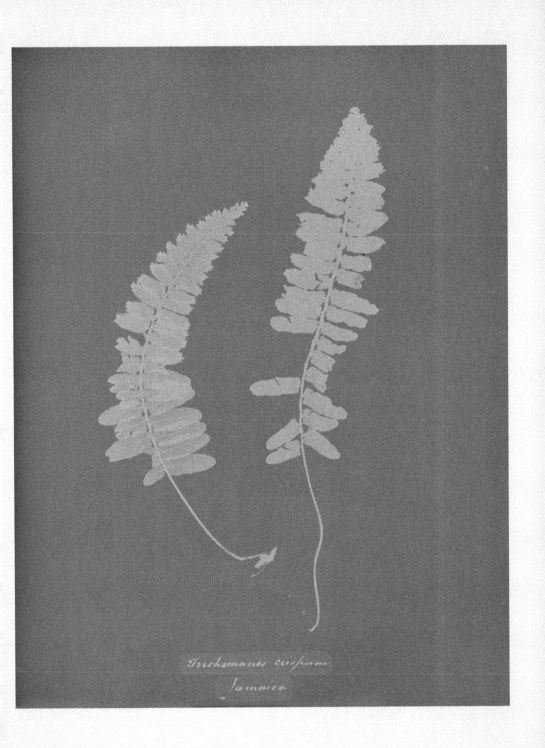

PLATE 79

Trichomanes crispum, Jamaica

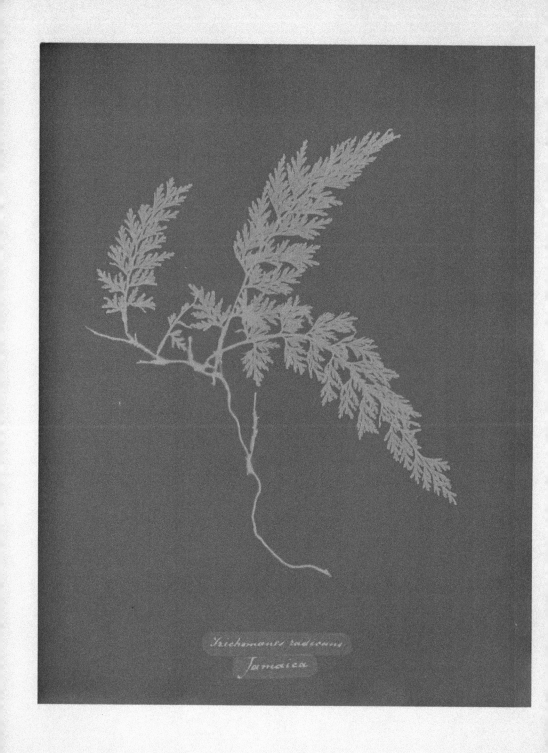

PLATE 80

Trichomanes radicans, Jamaica

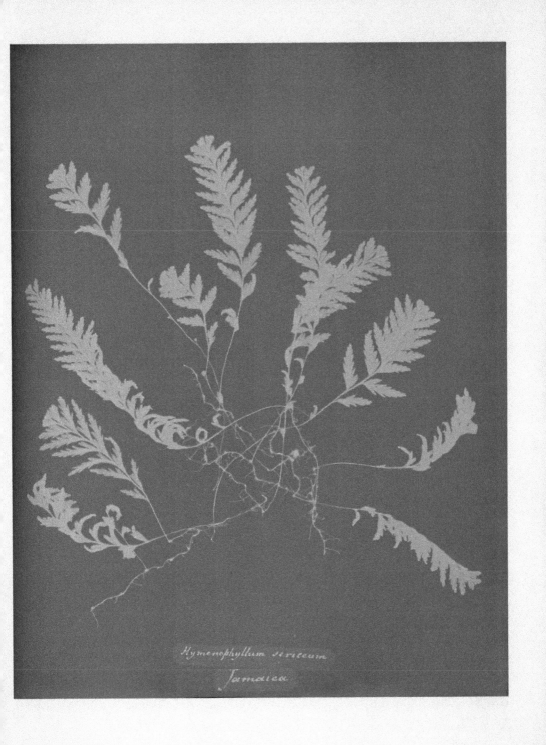

PLATE 81

Hymenophyllum sericeum, Jamaica

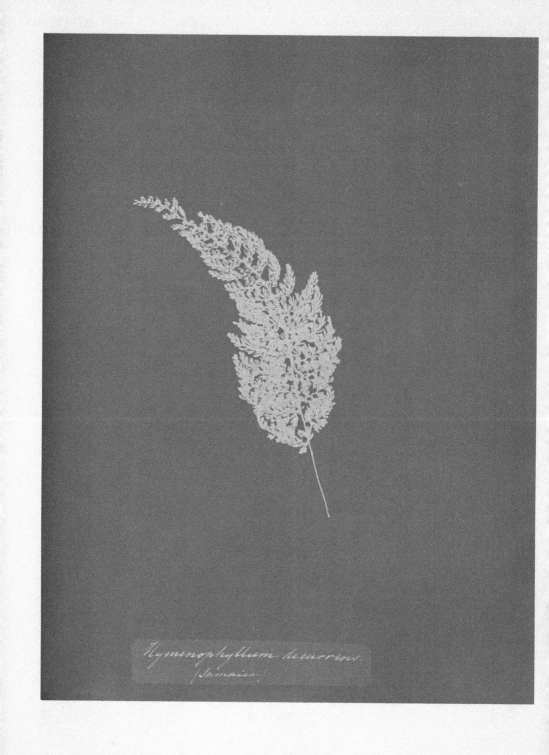

PLATE 82

Hymenophyllum decurrens, Jamaica

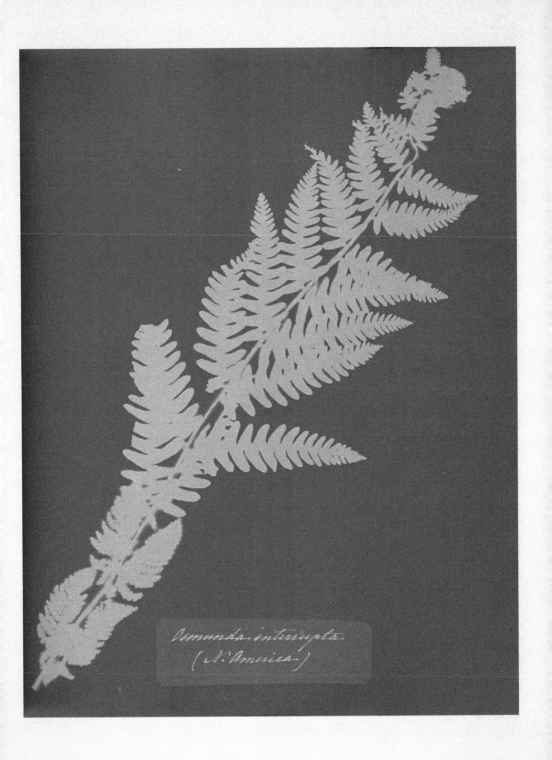

PLATE 83

Osmunda interrupta, N. America

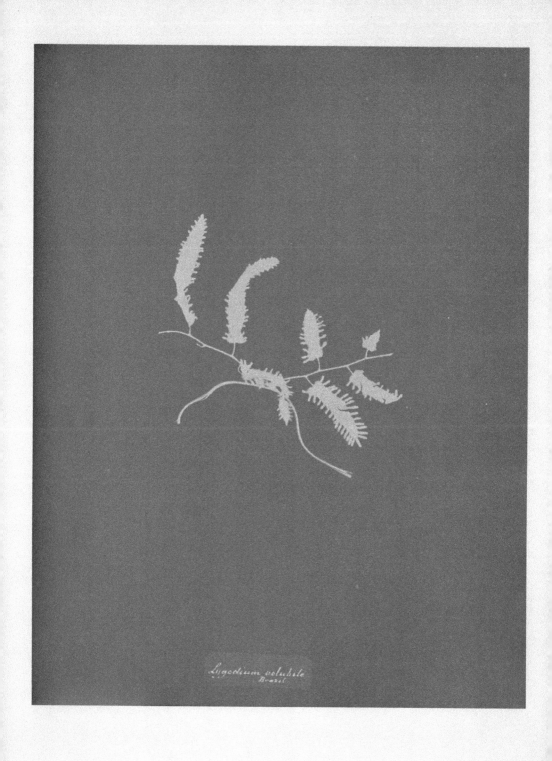

PLATE 84

Lygodium volubile, Brazil

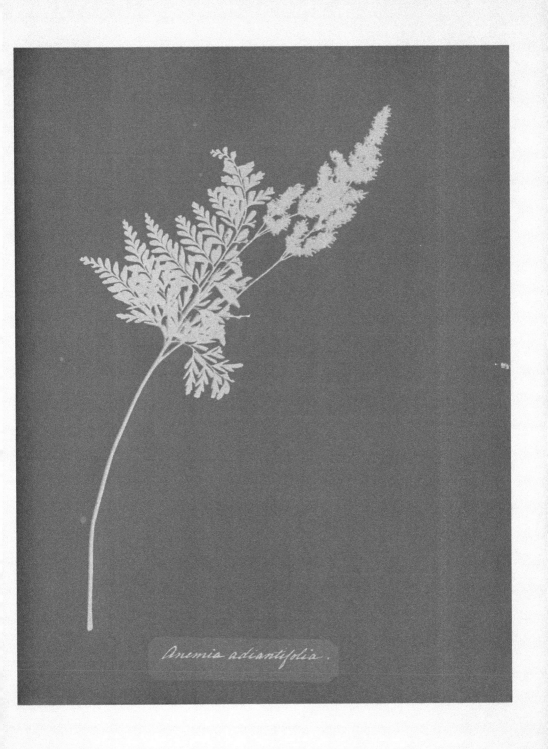

Anemia adiantifolia.

PLATE 85

Anemia adiantifolia

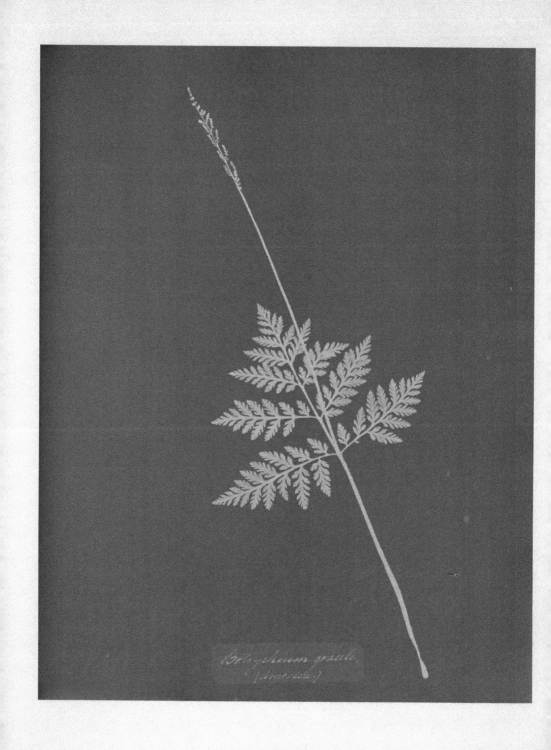

PLATE 86

Botrychium gracile, America

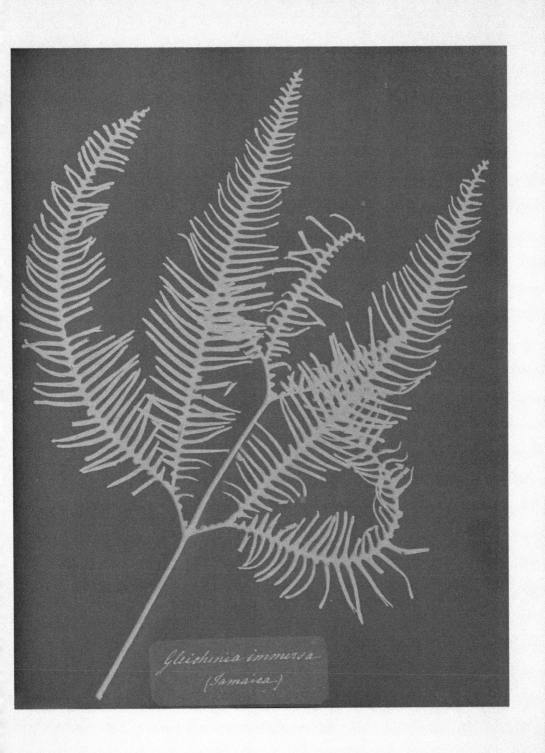

PLATE 87

Gleichenia immersa, Jamaica

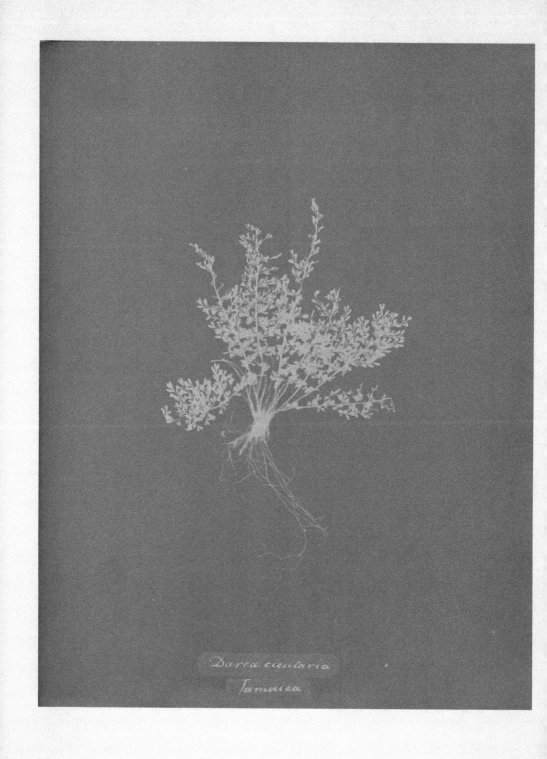

PLATE 88

Darea cicutaria, Jamaica

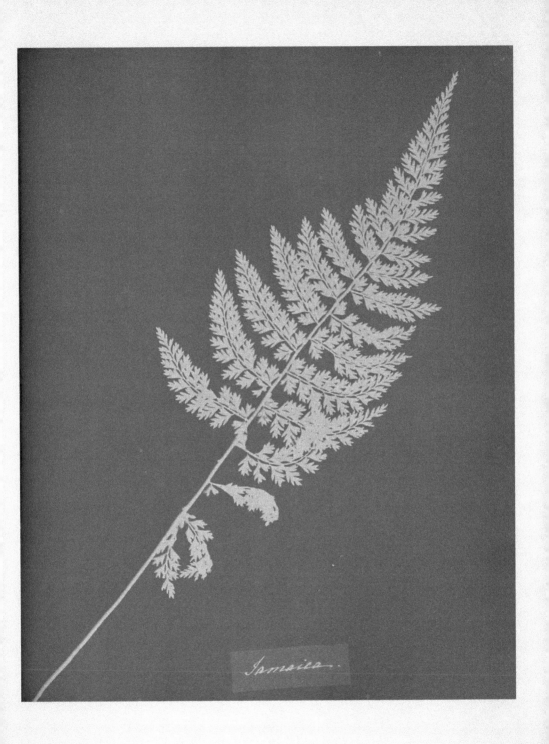

PLATE 89

Jamaica

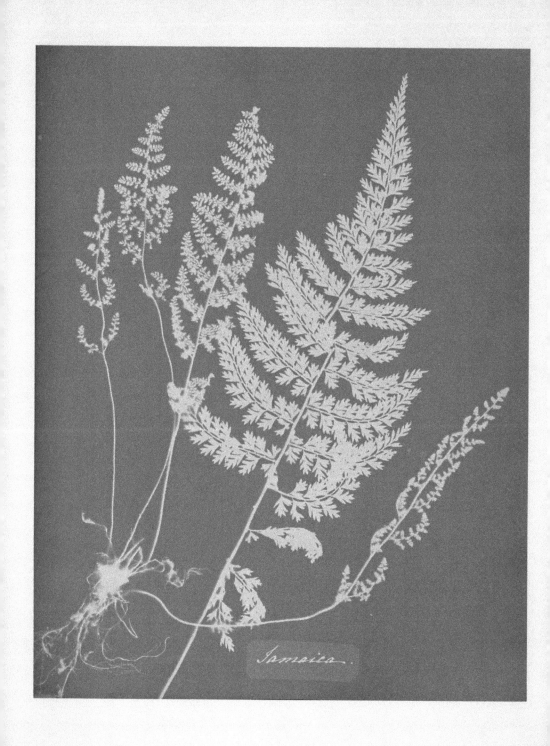

*Jamaica*

PLATE 90

Jamaica

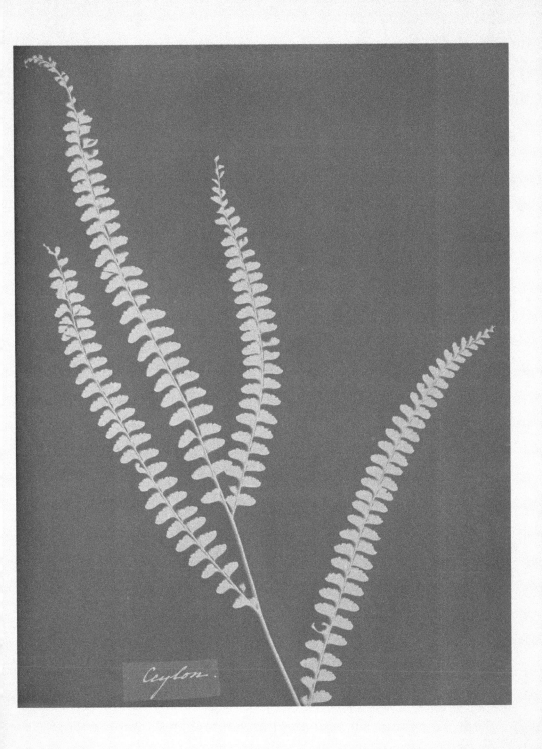

PLATE 91

Ceylon

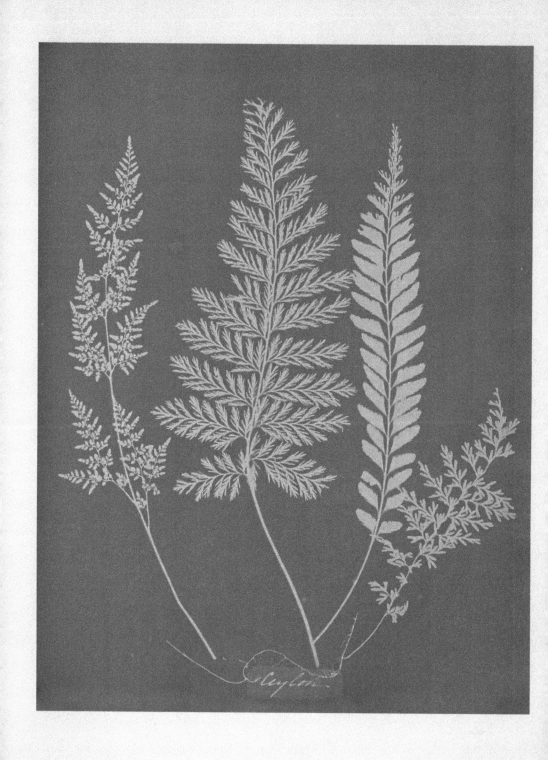

PLATE 92

Ceylon

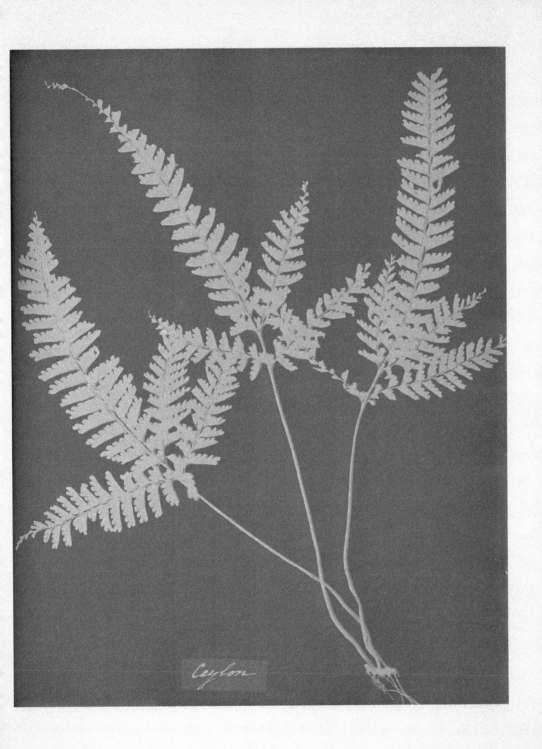

*Ceylon*

PLATE 93

Ceylon

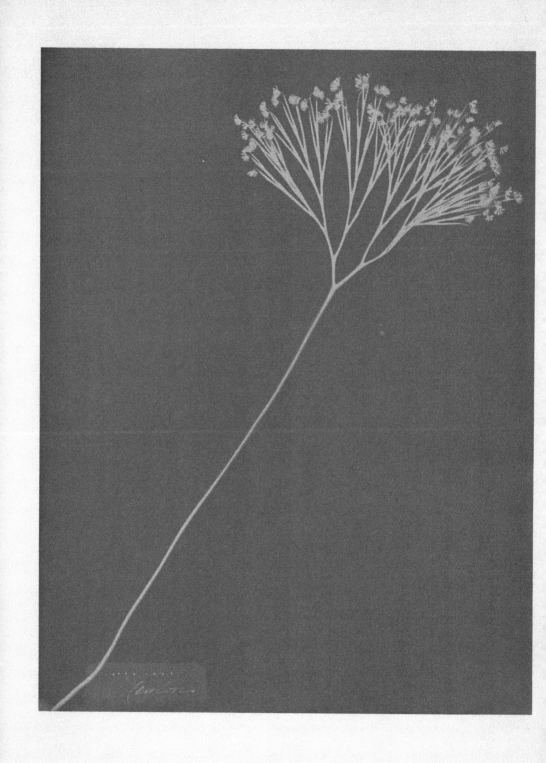

PLATE 94

Ceylon

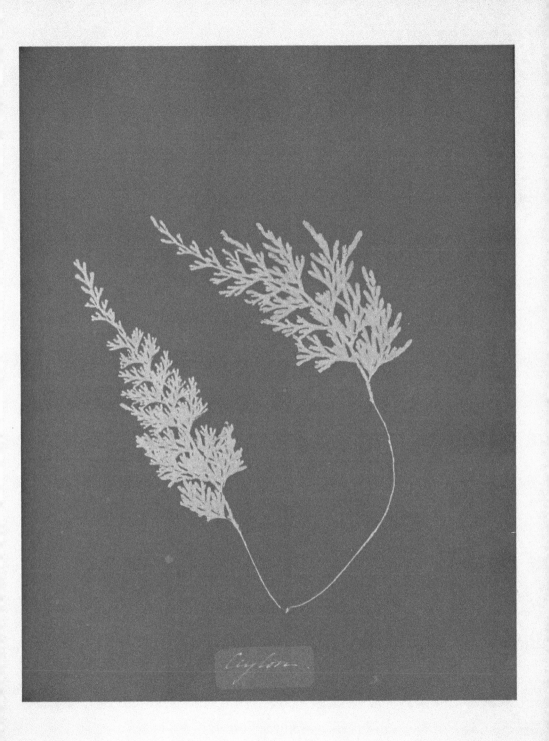

PLATE 95

Ceylon

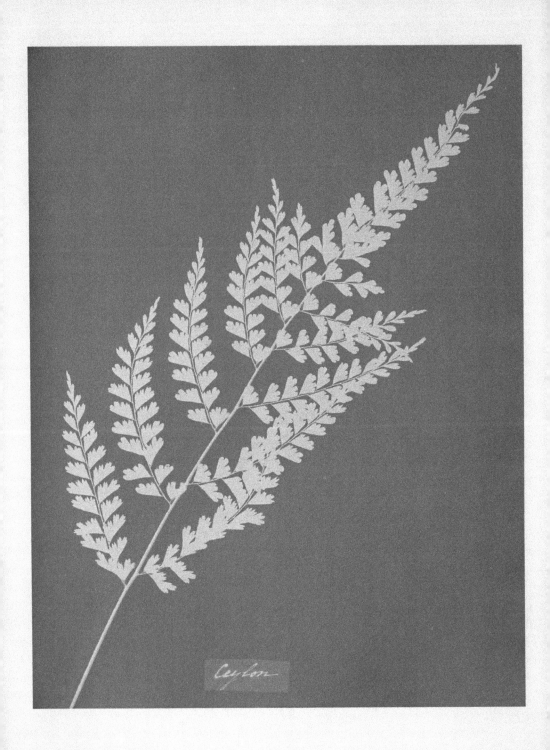

*Ceylon*

PLATE 96

Ceylon

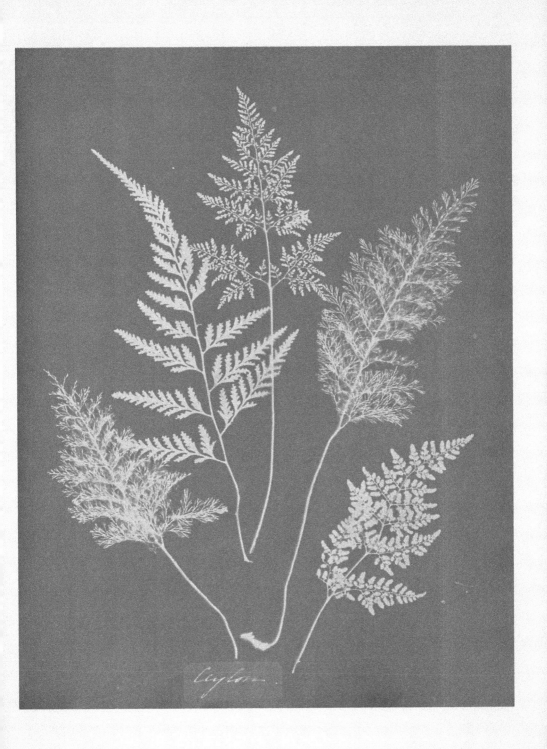

PLATE 97

Ceylon

# The Cyanotype or Blue Process

This process gives white impressions on a blue ground with diapositives or drawings on transparent or semi-transparent materials, and blue impressions on a white ground from negatives. It is commonly known under the names of "blue print process," "negative ferrotype process" and "ferro-prussiate process."

The process is indeed exceedingly simple. A sheet of paper, impregnated or sensitized, as it is termed, with a solution of ferric citrate and ferricyanate is impressed under a cliché, then immersed in pure water, whereby the image is developed and at the same time fixed. It is on account of the great advantages offered by its simplicity that this process is generally preferred by civil engineers and architects for the reproduction of their plans.

The sensitizing solution is prepared in mixing by equal volumes the two solutions following:

| | | |
|---|---|---|
| A. | Iron, ammonio citrate | 20 parts |
| | Water | 100 parts |
| B. | Potassium ferricyanate (red prussiate) | 15 parts |
| | Water | 100 parts |

Although the mixture keeps pretty well for a certain period in the dark, it is best to prepare only the quantity wanted for actual use.

The paper is preferably sensitized in operating as follows:

Take hold of the paper by the two opposite corners and fold it into a loop, lay it on the iron solution, the center of the sheet first placed in contact with the liquid, and then gradually spread it by lowering the corners with a little pressure. No solution should run over on the back of the paper; it would be a cause of stain. This done, and without allowing the liquid to penetrate in the paper, immediately take hold of the two corners near the body and withdraw the paper by dragging it over on a glass rod for this purpose fixed on the edge of the tray. Now pin up the paper to dry, which should be done rapidly, and sensitize a second time in proceeding in the same manner. If this second sensitizing be found objectionable, let float the paper for no more than ten seconds; of course this method of sensitizing is not applicable to prepare larger sheets of paper. In this case the paper is pinned by the four corners on a drawing board or any other support, lined with blotting paper and quickly brushed over with a sponge sparingly imbued with the sensitizing mixture, so as to wet the paper with a very small excess of liquid.

The rationale of this manner of sensitizing is to impregnate only the very surface of the paper with the ferric salts, and thereby to obtain an intense blue with very good whites, which latter it would be impossible of obtaining should the sensitizing solution be allowed to reach in the fibers of the paper, for, in this condition, it is impossible, owing to the exigencies of the process, to wash out thoroughly the iron salts to prevent the chemical changes which cause the whites to be tinted blue. It is for this reason that better results are also obtained with well sized papers.

The sensitizing should be done by a very diffused daylight, and the drying, of course, in a dark room. When sensitized the paper is yellowish green. It should be well dried for keeping, and rolled or wrapped in orange or brown paper and preserved from the action of dampness and of the air. It does not keep well,

however, no more than two or three months, perhaps, in good condition; but the sooner it is employed the finer the proofs, the better the whites and more rapidly is the paper impressed.

(…)

*Printing.*—The process we describe yields negative impressions, that is a positive image from a negative cliché, and a negative image from a positive cliché, exactly as the silver printing-out process ordinarily employed in photography. Consequently, for the production of non-reversed proofs from plans, etc., the original drawing should be placed face downwards on the glass plate of the printing frame, and, upon the back, the sensitive paper is laid and pressed into perfect contact by means of a pad, felt or thick cloth.

The printing frame is that used by photographers. The lid is divided, according to the side, in two, three and even four sections, held by hinges and fastened for printing by as many cross-bars, in order that by opening one section, from time to time, the operator can follow the progressive changes resulting from the action of light on the iron salts. To print, the frame should be placed in the light in such a manner as the luminous rays fall perpendicularly upon the drawing or cliché. The reason of this is obvious, since the sensitive paper is not in direct contact with the design, but separated by the material upon which it is drawn.

During the insolation—whose time depends necessarily from the more or less transparency of the cliché, and, also, from the intensity of the light—the paper assumes first a violet tint, which gradually intensifies to a dark shade; then this tint fades, becomes brownish, then pale lilac, while the parts under the lines—that is, the design—upon which the light has, therefore, no action, are visible by keeping the original yellow-green tint of the prepared paper. It is when the lilac color is produced that the exposure is sufficient.

(…)

The image is developed and fixed by washing in water two or three times renewed. The water must be free from calcareous salts; these salts converting the iron into carbonates which impart an ochrey tinge to the proof. Rain water—any water in

which no precipitate is thrown down by the addition of a few drops of a weak solution of silver nitrate—may be used with safety.

During the development the ground takes a blue color which rapidly intensifies, while the iron compound, not acted on and imparting a yellow green tint to the design, is washed out from the white paper. If the print has not been sufficiently exposed the ground remains pale blue, more or less; the reason has been explained. In this case the development should be done quickly, as the blue is always discharged by washing. On the other hand, whenever the whites are tinted by excess of exposure, they can be cleared partly or entirely by a prolonged immersion in water, but the ground is also to some extent lightened.

When the proof is well developed and fixed, that is, when the soluble iron salts are eliminated, the blue color can be brightened by adding to the last but one washing water a small quantity of citric acid, or of potassium bisulphate, or a little of a solution of hypochlorite of lime (bleaching powder).

– 'The Cyanotype or Blue Process',
from *Photographic Reproduction Process:*
*A Practical Treatise of the Photo Impressions*
*Without Silver Salts* by P.C. Duchochois, 1891

# Biography of Anna Atkins

Anna Atkins (1799–1871) was an English botanist and photographer known for her pioneering work with cyanotype photography. She used the innovative technique to document algae and fern specimens, becoming widely recognised as the first female photographer and the first person to publish a book featuring photographic images.

As a child, Atkins was exposed to the world of science through her father, John George Children, a respected scientist with connections to the Royal Academy and British Museum. These connections granted her access to a scientific community that was typically restricted for women at the time. Under her father's tutelage, Atkins ventured into scientific illustration, creating hand-drawn images to accompany her father's translation of Jean-Baptiste de Monet Lamarck's *Genera of Shells* (1823), although her interests later focused on botany.

In 1825, Atkins married John Pelly Atkins, a wealthy West India merchant who shared her passion for science. This marriage provided her with the time and resources to pursue her botanical interests. Through her father's connections in the Royal Society, Atkins had the opportunity to learn about developments in photography from renowned figures such as William Henry Fox Talbot and Sir John Herschel. Talbot and Herschel played pivotal roles in the invention of early photographic methods during the first half of the nineteenth century, with Herschel developing the cyanotype process – a means of capturing a photographic image using chemically treated paper and sunlight.

Unlike many other early photographers, Atkins had the opportunity to learn this method directly from Herschel, allowing her to master the process. Her mastery of the cyanotype technique, along with her botanical expertise, led to her groundbreaking contributions in science, photography, and publishing.

An enthusiastic collector of algae specimens, Atkins embraced Herschel's groundbreaking technique to meticulously document her collection with intricate detail. Over the course of a decade-long project, she produced numerous volumes of cyanotype prints, capturing the botanical specimens she encountered in the British Isles. The first installment, *British Algae: Cyanotype Impressions*, made its debut in 1843, marking the world's first publication to feature photographic images. These stunning visual records showcased a wide array of algae species never before witnessed. This monumental undertaking comprised nearly 400 cyanotype impressions, published across multiple volumes.

After the passing of her father in 1853, Atkins embarked on a new venture, capturing cyanotype impressions specifically dedicated to British and foreign ferns, collaborating with her close friend, Anne Dixon. Fueled by their shared passion for botany, this project resulted in a smaller-scale collection produced as a gift for Dixon's nephew, Henry Dixon, who also shared their love for scientific exploration. The duo created 100 plates of cyanotype impressions, resulting in only two copies of the work itself, one gifted to Dixon and the other to her nephew.

Atkins' tireless efforts continued until her passing on June 9th 1871 at Halstead Place, Kent. Her pioneering technique and groundbreaking publications established her as a significant figure in the fields of botany and photography, reinforcing the recognition of photography as a scientific tool. Despite the delayed reception of her groundbreaking work, she's remembered as a visionary who pushed the societal boundaries of Victorian England. Defying conventions and paving the way for future generations of women, Atkins left an indelible mark in both the scientific and artistic spheres.

# MORE FROM ARTS MEETS SCIENCE

## OLIVER BYRNE'S ELEMENTS OF EUCLID

The First Six Books with Coloured Diagrams and Symbols

By Oliver Byrne

ISBN: 9781528770439

In one of the most stunning expositions of mathematical publishing, Oliver Byrne combines Euclid's geometric theories with vibrant colour proofs, turning what was already a cornerstone academic text into a pedagogical work of art.

## WERNER'S NOMENCLATURE OF COLOURS

Adapted to Zoology, Botany, Chemistry, Mineralogy, Anatomy, and the Arts

By Patrick Syme

ISBN: 9781528717052

Read & Co. presents this new edition of *Werner's Nomenclature of Colours*. First published in 1814, this small volume comprises a collection of 110 swatches displaying nature's colour palette together with their poetical descriptions.

# MORE FROM ARTS MEETS SCIENCE

ERNST HAEKEL'S
ART FORMS IN NATURE

A Visual Masterpiece of
the Natural World

By Ernst Haekel

ISBN: 9781528773133

In a beautiful celebration of the natural world, *Ernst Haeckel's Art Forms in Nature* is a masterful union of science and art. This volume is comprised of 100 illustrated plates, featuring stunning watercolour paintings and pencil sketches.

Printed in the USA
CPSIA information can be obtained
at www.ICGtesting.com
LVHW052153131023
760911LV00032B/348/J